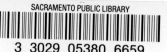
BILLBOARD ART

BILLB

CHRONICLE BOOKS

OARD ART

Sally Henderson & Robert Landau

Edited by
Michelle Feldman

With an introduction by David Hockney

This book is dedicated to our parents

Library of Congress Cataloging in Publication Data

Henderson, Sally.
 Billboard Art.

 1. Billboards—History. I. Landau, Robert, joint author. II. Feldman, Michelle. III. Title.
HF5843.H462 741.67 80-12009
ISBN 0-87701-167-2

10 9 8 7 6 5

Book and cover design by John Beyer.
Cover photo by Robert Landau.
Composition by Design & Type, Inc., San Francisco.
Printing by Dai Nippon, Tokyo.

Chronicle Books
One Hallidie Plaza
San Francisco, CA 94102

Bibliography:

Barnicoat, John. *A Concise History of Posters.* New York: Oxford University Press, 1972.

Battcock, Gregory. *Super Realism.* New York: Dutton & Co., 1975.

Carr, Stephen. *City Signs and Lights.* Boston: Boston Redevelopment Authority, 1971.

Claus, R. James and Karen Claus. *Visual Environment.* Ontario: Collier-Macmillan Canada, Ltd., 1971.

Foster & Kleiser, Pacific Outdoor Advertising. *Analysis Draft Environmental Impact Report.* Los Angeles, 1974.

Gottschall, Edward and Arthur Hawkins. *Advertising Directions.* New York: Art Directions Books Company, 1959.

Knobler, Nathan. *The Visual Dialogue.* New York: Holt, Rinehart & Winston, 1966.

Lippard, Lucy. *Pop Art.* New York: Praeger Publishers, 1966.

Margolin, Victor, et al. *The Promise and the Product.* New York: Macmillan Publishing Co., 1979.

McLuhan, Marshall and Quentin Fiore. *The Medium is the Massage.* England: Penguin Books Ltd., 1967.

Outdoor Advertising Association. Outdoor Advertising. 1928.

Plagens, Peter. *Sunshine Muse.* New York: Praeger Publishers, 1974.

Rowsome, Frank, Jr. *The Verse by the Side of the Road.* Stephen Greene Press, 1965.

———. *They Laughed When I Sat Down.* New York: Bonanza Books, 1959.

Picture Credits:
(All photos by Robert Landau except as listed.) Artkraft-Strauss: p. 23 (2), p. 24 (2), p. 25 (2), p. 26, p. 27 (left); Bettman Archive: p. 8, p. 9 (center top), p. 10, p. 11 (3), p. 14 (2), p. 15 (3), p. 16 (2), p. 19 (left), p. 20 (left), p. 21 (bottom 2), p. 22, p. 40; Black Star: p. 73 (right 2); Margaret Bourke-White/Life Picture Service: p. 37 (right); Citroen Archives: p. 27 (right); Fairleigh Dickenson: p. 12, p. 19 (right), p. 20 (top right 2), p. 31 (bottom right), p. 32 (2), p. 34 (right), p. 35; Walker Evans/Library of Congress: p. 33, p. 36 (right); Foster and Kleiser: p. 13, p. 17 (right 2), p. 20 (bottom right), p. 28 (2), p. 29 (4), p. 30 (2), p. 31 (left and top right), p. 34 (left), p. 36 (left), p. 38 (left), p. 41 (right 2), p. 42 (4), p. 43, p. 57 (top left), p. 58, p. 60, p. 61 (2), p. 77 (right), p. 84 (top right), p. 87, p. 90 (top left and sequence), p. 91 (top right), p. 92 (2), p. 93 (bottom right), p. 97 (left), p. 109 (right), p. 112; Japan Plastics Advertising: p. 72, p. 100 (bottom left); André Kertesz: p. 18; Dorothea Lange/Library of Congress: p. 37 (left); Lioté Publicité: p. 17 (left), p. 21 (top right); More O'Ferrall: p. 47, p. 51 (left), p. 70 (right), p. 100 (top left), p. 106; Phillip Morris Archives: p. 38 (right); National Advertising: p. 97 (right); Pacific Outdoor Advertising: p. 49, p. 50 (right), p. 51 (right 3), p. 53 (right), p. 54 (bottom 4), p. 55, p. 56, p. 57 (bottom left and right), p. 62 (right 3), p. 63, p. 66 (left), p. 67, p. 77 (left 2), p. 80 (right), p. 84 (left); Len Rubenstein: p. 64 (bottom left); Vogel Outdoor Advertising: p. 52 (2), p. 53 (left), p. 74 (right), p. 76 (right); Wide World: p. 39, p. 41 (left), p. 44, p. 45, p. 46 (2), p. 50 (left), p. 70 (left), p. 73 (left), p. 76 (left 2), p. 90 (bottom left).

Acknowledgments:

Thanks to John Andrews, Cliff Badger, Jacqueline Baraduc, Ross Barrett, Herbert Bayer, Joe Blackstock, Paul Block, Hal Brown Jr., Virginia Crane, Linda Curttright, Dr. James Fraser, Roger Genser, Harry Goss, Joel Gottler, Herman Hirsch, M. Ikeda, R. Jain, Susan Jenkinson, Jean-Claude Lemagny, Jean Jacques Liote, Jim Novak, Marianne Ochoa, N.D. Purday, Len Rubenstein, Dick Schuettge, Hank Seidl, Giuliano Serafini, Ann Shannon, David Shapiro, Jonathan Starr, Peter Steinlauf, Mike Tobey, Jane Vandenburgh, And special thanks to Glenn Johnson.

Contents:

Introduction:
On Billboards, Art, and Artists

The whole idea of big signs came from the fact that people couldn't read. The barber's pole told you where the barber was. You didn't have to be able to read the word "barber." The pub that was called "The King's Head" had just a picture of a king's head. You didn't have to be literate to know that it was the king's head. These signs were decorative in a nice way. They were made as attractively as possible.

If you like the art of the poster, then you really like the art of the billboard. The billboard can be art, if an artist does it. It's like the argument about photography being an art or not. If an artist uses the camera, it's an art. If not...?

A commercial artist is, after all, doing commissioned work in the sense that he can't just follow his own fancy, while a fine artist can. But this shouldn't necessarily make a difference— not the difference that makes one art and one not. The movies are a good example. I'm sure few people who made movies in Hollywood set out to make a work of art. But some did make works of art—and some did not. Those that weren't art just disappeared. They became very ephemeral and vanished. *City Lights* is a great work of art and it speaks to all people. And it will speak in the future just as much as it did in the past. The time doesn't matter. It's actually about

people's feelings and it's quite deep about them —looking at them in a funny and sad way, the way people do look at life.

In California, the billboard does seem to embellish the environment, as it does in a lot of places, actually. Even in France in the countryside you might see a "Pernod" sign where it's painted on the side of a building. In fact, when there are no signs, no boards at all, I think it's a little suspicious. For example, I went to stay in Bedford Village, which is about forty-five minutes out of Manhattan—very pretty countryside. People said, "It's like England. Very green." But after I'd been there about a week, I thought, "There's something wrong here. It's not like England at all." It was too neat, too manicured. Then I said, "There're no signs at all." You're not allowed to put signs up in Bedford Village. This tells us that this is not the real country. If it were really the country, the plumber, the butcher and everybody else would have put up signs to let you know where they were. In England there are real people who live there and who have a trade and therefore have to make their signs. Whereas in Bedford Village, the people are stockbrokers from New York who want to live in the country— or their idea of the country—so there are no signs at all. There's a manicured look to it that tells you in the end that it's not real.

In Peter Blake's book FORM FOLLOWS FIASCO, there are before-and-after photos of wonderful streets full of signs and life and everything. That's "before"—"after" has been sanitized. The streets look totally dull and lifeless.

Billboards are like buildings in that they're part of the clutter of the city—yet the architecture of the past twenty years has been far more of a blight on things than billboards are. I think we've lived through the worst twenty years of architecture ever. In Los Angeles it doesn't matter much because Los Angeles is a new city and the buildings will probably be pulled down anyway. In Bradford, England, where I was born and brought up, the center of the city was completely Victorian and had been built in about 1870. Rather grand Victorian buildings, they were, and the city was, in its way, quite beautiful. Then they started pulling things down and there was a short period when people referred to this as "improvements." But then local people stopped calling this "improvements." They did not attack the new architecture, but something told them that what was being built wasn't always an improvement. To destroy all old buildings is destroying the remnants of the past. If you have a place with no old buildings, it's like having a human being without a memory. Remembering things is part of time passing. You need it.

Right now we're going through a period where we are relooking at past history, which is a natural process, as history gets rewritten all the time. The history of modern art is being rewritten —causing confusion to some people. This is perfectly natural and I would have thought that even that confusion is reflected in the lack of confidence sometimes shown in the style of billboards. I'm sure, though, that this lack of confidence won't last long. Some imagination will get to work.

In Los Angeles, everything's new and it doesn't matter as much. What's exciting is that probably thirty or forty years ago these houses weren't here. Nobody lived here—nobody at all. But every part of London has had somebody living there for an awfully long time. The land has been cultivated for at least a thousand years. New York two hundred years ago must have been like Los Angeles now. Buildings were just put up, then pulled down, until the city slowly coalesced into something. I think that this makes Los Angeles very exciting right now.

Sunset Boulevard is fun to drive through, especially when you know the billboards change every month. It's sort of like a little gallery to drive down. The interesting ones are made to be seen at twenty miles per hour—you have to take them in at that speed.

The American billboard is a little different from those in England. In England in the subways they have a lot more billboards than they do in New York. There is advertising in every station, everywhere. Without them the subway would be a bit dull. They provide a lot of color.

You can trace posters to fine art sources. There's a delay period and then they come around. I think Pop Art in itself had an influence on the world of advertising. Fine artists refined a lot of ideas from the world of advertising and made the art even bolder and better. Better

images. After all, poster art has always had people who would steal from anywhere—and quite rightly. So the fine artists took it back.

To make something not photographic means to draw it. People get bored with photography. Everybody is more interested in a drawing, partially because they know the skill involved. There is skill involved in photography, but it is a much more easily acquired skill. If you sit and draw on the street, people will come around and look. The idea of watching somebody recreate is appealing to everybody. I mean, I draw in the streets and people always come up and want to look, whereas I think that if you're just taking a photograph, they think they already know what it will look like.

People used to go into an art school and not learn to draw, not even the fundamental principles of how to depict something. Volume can, after all, be taught quite well. In England, I was one of the last people to go through the old art school system, which was very academic. You just draw from models all the time. For four years I was at the art school in Bradford and that's all I did. But at the end of four years you do know quite a bit about drawing and you learn how to use it and to depict something in front of you—to use it imaginatively.

I remember suddenly about 1961 or 1962 when Frank Stella was said to be painting without drawing. If you cannot draw, all pictures of the visible world are going to finish up being photographic or primitive. But with drawing, painting can go in a more interesting direction. And drawing has to be taught. Even Picasso had to learn to draw—his father was an academic drawing teacher. Cartier-Bresson was taught to draw and he claims that that is why he developed a good eye—because he learned to notice a lot of differences.

The scale of a painting or a billboard depends

upon where it's seen from. If you put a billboard high up on Sunset Boulevard, the scale of it has to be quite big. From where you see it, it won't look that big. If you put a poster up on the street in London you're going to be much closer to the actual scale. The billboard can be much smaller and still make the object look big. The billboards along Sunset are designed to be seen from a distance. When you get close they look a bit crude, but from the street it all looks very effective. The scale isn't chosen for aesthetic reasons, but for practical ones, whereas in an ordinary artist's work, he chooses what size the painting should be. He chooses his scale for aesthetic reasons.

I wouldn't know how to work on the scale of a billboard. There is obviously some method of how you do it. I'm working on a painting now that is the biggest that I've ever done—twenty feet long.

I did do a drawing for the owner of a restaurant in Hollywood and he's going to have it painted on the billboard above the building, so that what you will see is the actual place with a colored drawing of the place above it. The idea of them putting a billboard above the place itself is a very interesting one.

Buildings should be decorated again. The ornament should reappear, as I think it will. That's against Bauhaus, of course. They hated ornament. Bauhaus was good in its time for clearing away a lot of debris, but the late Bauhaus influence on architecture is now making new debris. The ornament on buildings —it's sure to come back.

From a conversation with
DAVID HOCKNEY
April 1980

1
The Beginnings of Billboard Art

The birth of public visual communication can be traced to cave paintings created between 15,000 and 10,000 B.C. This mural in Lascaux, France, was done during the Paleolithic Age.

Outdoor messages in hieroglyphics were displayed on obelisks in Egypt over four thousand years ago.

In 1871, Frederic Walker's poster for the play "Woman in White" introduced a more romantic approach to poster art than had been the norm.

Public communication has fulfilled a human need from the Stone Age onward, and man has communicated his visual ideas openly for others to admire. On cave walls in Altamira, Spain, and Lascaux, France, wounded bison are shown collapsing, and bull and antelope forms stampede. The murals were created sometime between 15,000 and 10,000 B.C., but we will never know their purposes for certain. Perhaps the animal figures were magical talismans to assure a good hunt, or produced after the fact to commemorate the antelope that got away. From these simple beginnings the art of public persuasion, or advertising, developed.

The oldest known advertisement was discovered in the Egyptian city of Thebes. Written on papyrus over three thousand years ago, the ad is a poster offering a reward for a runaway slave. During the same period, Egyptian merchants were cutting sales messages into stelae, the stone tablets that were placed by the roadsides, and tall, square obelisks bore hieroglyphic stories.

Centuries later, wood-covered columns called axones told the order of Grecian public games, and slaves posted signs for Roman businessmen. And in Pompeii, nearly every wall was hung with a billboard message. The albums or tablets, buried by the eruption of Vesuvius in 79 A.D., called on voters to end graft and corruption

in their city. Ironically, advertising, which seems so fleeting, a thing of the moment, has outlasted these cultures; the advertisements have been preserved as artifacts of another time.

By the late 1400s, billposting was an accepted practice in Europe, and bills appeared all over city squares, on the sides of churches and on public buildings. This was a period of religious unrest, which spurred communication. Later churches as St. Paul's Cathedral in London became prime locations for bills posted to air grievances publicly.

When lithography was invented by Senefelder, a Bavarian, in 1796, the scope of advertising expanded. The lithography process facilitated the development of aesthetic qualities in advertising design. The technique, based on the natural repulsion between grease and water, involves printing off a flat stone or metal plate. A design in a greasy medium is placed on a surface; then water and printing ink are applied. The greasy design repels water and absorbs the ink, but the wet parts do not.

By 1870, technological advances in mechanization had greatly improved the poster art. During the Industrial Revolution machines were invented for paper folding and cutting, printing, and production of lithographic halftones. Halftones gave three-dimensional qualities to images by breaking the picture up into tiny dot formations.

Under the guidance of such men as French artist Cheret, the look of advertising underwent a change. Cheret helped to pioneer the use of color in the modern poster. His work featured wonderful color effects that drew the viewer's attention to the poster and then to the product. Frederick Walker, an Englishman, is credited with one of the first art posters. Done in 1871, the black and white work appeared in London to announce the play "Woman in White." The poster was unusual in that Walker renounced the straightforward, literal, mundane approach of his contemporaries in favor of a romantic, fanciful, stylized treatment. His work established a standard of grace and beauty for future commercial artists.

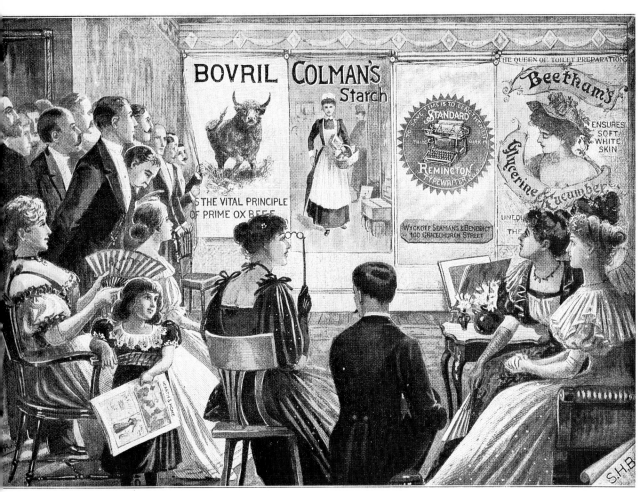

Poster collecting became a fashionable hobby as enthusiasts mounted them on canvases which could be rolled up and down like ordinary blinds.

National schools of poster art were established by the early 1900s; the leaders in the field were the Beggarstaff brothers in England, Mucha in Austria and Sutterlin in Germany. In the United States, Penfield whetted the public taste for sophisticated commercial art.

In addition to the poster and the one-dimensional sign, there had been many interesting and unusual attempts at outdoor advertising during the 1800s. The French, by means of mechanical apparatus, tried to spell words out against the clouds; eye catching light reflectors threw messages on the sidewalks of Paris. In the United States and many European countries models of goods for sale including all manner of large, three-dimensional hats and shoes were drawn through the streets by horses. Or advertisers hung sheets and banners on horses to give the public notice that a fresh troupe of musicians or circus performers had just arrived. But in the long run, advertisers found most of these means too cumbersome and ineffective, and in time, they were abandoned.

By the turn of the century, an unprecedented amount of economic growth had taken place in the industrialized nations of continental Europe, Great Britain, and the United States. Technological advances in production and rapidly increasing population density created vast new markets for information and products.

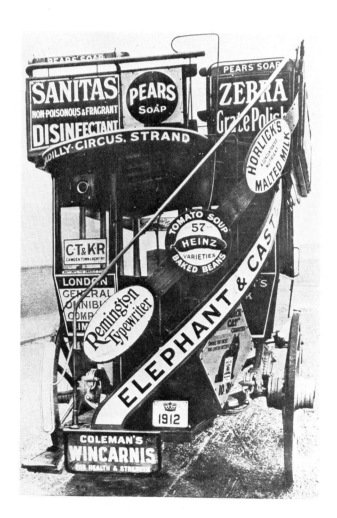

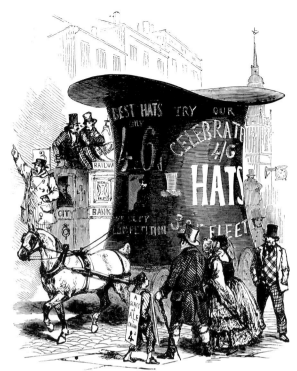

A horse-drawn bus circulates a variety of advertising messages through the streets of London in 1912 (left). In continental Europe, three-dimensional objects, such as this oversized hat (center), were successful advertising devices. Poster advertising was not confined to walls and fences. This human sign board (right), a forerunner of the sandwich board man, strolls along a Parisian street in the 1890s.

In addition, the British propensity for travel to foreign countries helped expand the international market for new goods. Britishers kept coming back from places like China and the West Indies bearing spices, fabrics and works of art. The burgeoning middle class, once it had had a taste of these luxuries, developed a real appetite for them. It provided a ready market for foreign imports and further domestic manufacture.

Great Britain epitomized Western social change in the field of expanding communications as well. In the late 1800s, for example, the first popular national daily newspaper circulated in England—the *Daily Mail*. It was a landmark publication, setting a precedent for current, easily accessible news and advertising. Again, as with such products as fabrics and spices, what had once been a luxury soon enough became a

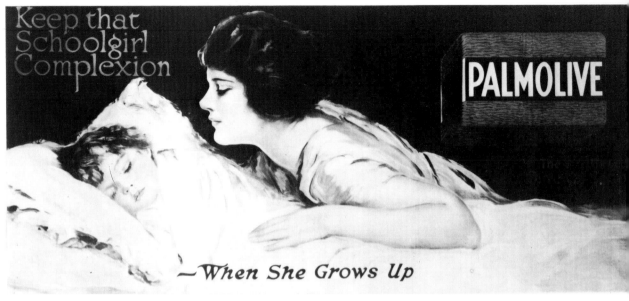

Keep that
Schoolgirl
Complexion

PALMOLIVE

—When She Grows Up

necessity. The reading public, once accustomed to a daily paper, came to expect it. This opened up a market for rival publications to circulate.

During the early 1900s, the modern methods of communication developed. In London's West End the first primitive motion pictures were being shown to enthralled audiences. During the same period such influential inventions as the still camera began to open new avenues for contemporary advertising.

Photography was a significant development, and although it was invented around the middle of the nineteenth century, its full effect on art and advertising imagery would not be felt directly until much later. The medium first caught on in a major way when the general public realized they could have accurate portraits made, and could spare the time and expense of commissioning an artist to render their likenesses in oils. Now the common man could be immortalized and remembered by his kin, just like noblemen and members of the upper class.

In those early days, photography had other, more mundane, uses—to catalog goods, for example. They could, however, record landscapes which, when printed on postcard-sized paper, showed people in countries around the world the true splendor of the pyramids or the Taj Mahal as no illustration possibly could.

The realistic image obtained by focusing

reflected light through a lens and onto film or plates coated with light-sensitive chemicals created such reverence for the process that photography was considered a science rather than an art. In spite of this attitude, a slow shock wave rumbled through the art world. Certainly a painter could not compete with the camera for its unrelenting detail. Where the camera simply recorded whatever stood before it, the painter, through personal interpretation, could imbue his image with emotional depth. In a larger sense, the invention of photography freed artists from the shackles of realism and allowed them to explore more abstract, cerebral and emotional modes of putting paint to canvas. And despite the fact that photography, from its inception, would continue to influence and alter the course of the art and, especially, the advertising worlds, the question of whether photography was in itself worthy to be called art would remain controversial.

Under the pressure of widening communications, cultural exchanges became richer and more intense. The fashions of Western society, its

buying habits, advertising and products, reflected a rapidly shrinking world. Newer, more sophisticated techniques were needed to sell to a public grown accustomed to commercial messages.

But during the early 1900s, contemporary advertising was still in its formative stages. The ads followed a common pattern, one of naive, simplistic melodrama. Thwarted love affairs were frequent themes. The ads were full of dismay about bodily ills, or dealt with questions over what to wear and eat. Models in the illustrations appeared in highly stylized artificial poses, and the actual advertising message, or the pictured product, were often so small and subtle they could almost be missed.

The tiny medicine ads, full of line illustrations showing every misery known to man, were the harbingers of things to come. They started effectively combining the power of faith, suggestion, and above all, the testimonial. The ads grew in number and size, filling the pages of newspapers and magazines, covering billposted walls.

The first testimonials were mostly prose—

The 1907 poster sales-man, traveling from town to town in horse-drawn trucks, often preceded the circus or the wild west show with announcements of the upcoming events.

they then became visual. "Before" and "after" illustrations would demonstrate the good luck, health and happiness of lovers or families wise enough to buy and use the product. The small ads crammed full of tiny, unreadable type began to disappear.

Gradually, around the turn of the century, advertisers realized that their products could be sold by connecting them to anyone blessed with beauty, glamour, or prestige. Advertising using such beautiful girls as the Kellogg Cereal "Sweetheart of the Corn," and the Eastman Kodak and White Rock Mineral Water girls gained its power by associating the product with beauty. Rather than point to the merits of the product itself, these ads highlighted the qualities of the person appearing along side it.

Selling by association is possible because commercial messages have both a literal, descriptive aspect, and a subliminal message. While the literal message is often more obvious, the subliminal element is subtler and more deceptive. Subliminally, the buyer is told that the glamorous qualities of the person endorsing the product can be obtained along with the product.

And so, celebrities began climbing on the advertising bandwagon, with unsophisticated endorsements. If a person as lovely and well dressed as some famous celebrity uses the product, surely the average buyer would be wise to

do the same. This attitude was one of the most important elements to inform the advertising of the new century. A poster could sell a product by appealing to no other need than a hunger for esteem and prestige.

Early developments in the art of manipulation through advertising arose directly from techniques used to market patent medicines in the United States and Europe. The makers of these nostrums were some of the first to begin advertising on a national scale and to try to peddle their products over entire continents.

In those early days of patent medicines, media advertisers, merchants and vendors came to realize the importance of outdoor advertising as a secondary marketing tool, to be used in conjunction with newspapers and magazines. The

signs were small by today's standards, but they could show up anywhere and remind the customer about the product up to the very last minute he walked into the store.

In addition to the makers of patent medicines, traveling circuses, theatrical troupes and boxing matches gave outdoor advertising a boost to its ever-expanding sphere of influence by placing advance posters in each city and town where the event would travel. Salesmen—intent on turning a profit on billboard posting—offered to go ahead of a circus, town by town, from one coast to another, posting the coming attractions. These billboards and poster salesmen spread their business via horse-drawn trucks needed for the long trips across empty prairies, and soon the business of circus advertising became competi-

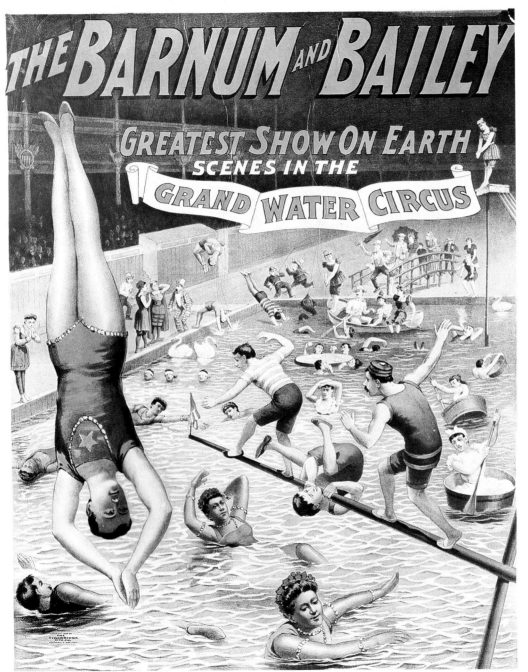

Early circus and Wild West show posters dazzled the viewers with exotic imagery. Posters like these are now valued as collectors' items.

tive. Articles in early *Billposter Magazine* spoke harshly of circus agents who wanted "graft" for selling circus ads in their city.

Barnum and Bailey and their "Greatest Show on Earth" traveled across the United States and Europe, along with Western performers like Buffalo Bill's Wild West and Congress of Rough Riders. The advertisements for these shows often pictured exaggerated scenes of the featured acts. Exotic animals being lassoed and tamed, women with mermaid tails, and bizarre men with no body at all or perhaps half human and half animal, were shown in detail.

The circus posters represented the state of the poster art at the time; they included some of the best and most creative advertising the public had yet seen. Today many of these lithographic landmarks are valued as collectors' items.

In every country, as billposting first became popular, children were usually given handfuls of posters to glue to any available wall. When certain fences and walls were considered the best for advertising to passersby, one poster was pasted atop another without regard for the other's

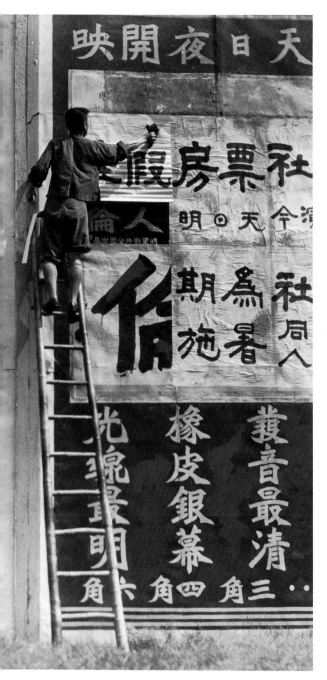

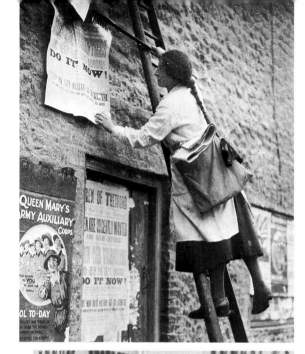

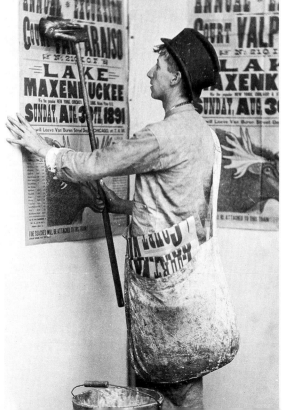

Billposting is a form of communication common to all cultures. The Chinese have relied on posters to disseminate news and to announce cultural events for centuries (left). A girl at Thetford, England, carries out billposting chores during World War I (above right), and a poster for Lake Maxenkuckee is brushed down on a wall in Chicago in 1891.

message. This has always occurred in metropolitan areas, and the abuse is commonly practiced today by concert promoters and political campaigners.

By the turn of the century the British had tremendously increased production and marketing in their country, but after the first decade of the twentieth century, nothing could match the pace at which Americans began to spend and consume. Advertising kept up with this pace. Without a long-lived traditional culture and the assurance of well-defined roles and symbols, people in the United States had to settle for those comforts and satisfactions that could be bought.

The lack of signage laws regulating the size and placement of outdoor ads allowed anyone to put up anything in the environment and call it marketing. As a result, the urban and rural landscapes of the United States were more heavily congested with signs than was the case in Europe. The question of visual clutter, and its impact on the environment, was raised before the advent of the automobile.

To insure a poster's visibility for any length of time, permission to post finally became a requirement. Permission had to be purchased from the owner of the wall or fence and the billposter then retained his space by painting his name all over the posting area. And at this juncture, which varied in time from country to country,

the outdoor advertising company—one man selling his poster area to an advertising client—was born.

Soon, in heavily trafficked areas, square or rectangular billboard structures built from two pieces of wood were put up by billposters whose services became more sophisticated as they sold space on their "billboards." The term "hoarding" was used in England as a reference to the wood enclosure around construction work where posters were almost always placed. Initially, billboards were built out of rough lumber, but after the turn of the century, almost all of the signs were made with finished lumber in a tongue-and-groove construction.

To deal with the early abuses that occurred from unlimited posting of signs, organizations met in the United States between 1872 and 1912 to set standards for billposting.

The eight-, twelve- and sixteen-sheet poster had been very popular in the United States up until this time, but the standard image, measuring 19 feet 6 inches by 8 feet 8 inches, then became the norm. Because of the trend in lithography toward production of a standardized twenty-four sheet poster panel, it became appropriate to set a regular size for poster panels and billboards.

Originally, the twenty-four sheet poster was actually printed on a lithographic press and each of the twenty-four sheets was posted separately

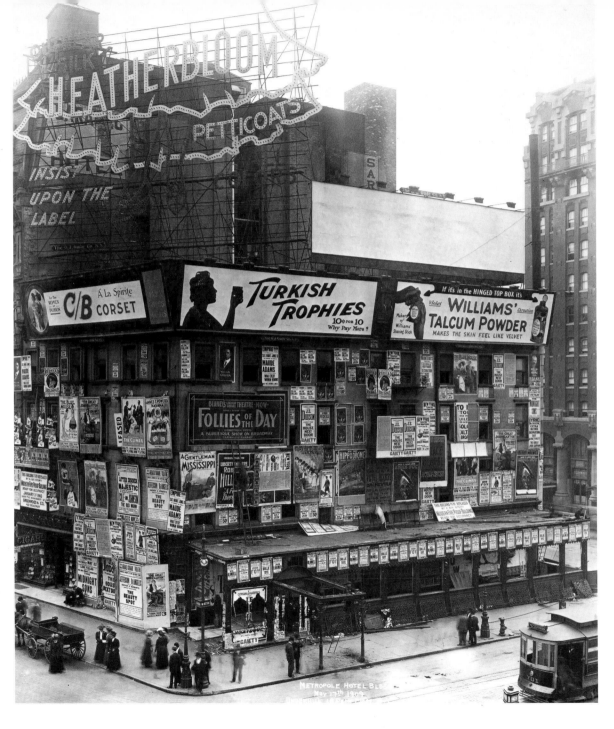

Even before the invention of the automobile—and long before environmental legislation that would seek to govern signage was considered—the possibility of a visually cluttered landscape was foreseen (left). A busy day in New York at the Metropol Hotel on Park Place in 1909. Both hand-painted billboards and electrical displays line the roof of the hotel, while the facade is covered with small lithographic posters.

With stepped-up industrialization, billboards proliferated in metropolitan areas. Wooden fences and wall posters surrounding construction sites soon gave way to more stylized displays. In 1924, billboards on San Francisco's Market Street featured the sculptured maidens which are called "lizzies" in the trade.

to make up the image. Today, with modern offset presses, sheet sizes are much larger and the standard-sized poster is actually put up in ten sheets.

Ads for "gasoline buggies" appeared in newspapers around 1896, placed by automakers Duryea and Winton. These vintage ads were rather quiet and hesitant at first. One for Duryea showed a bundled-up figure sitting in a tiller-steered car, not looking terribly happy. But the ads helped disseminate the idea of automobiles and got the public familiar with them. Although the car was still essentially a status symbol, its increasing popularity and importance were soon acknowledged by the British government, which

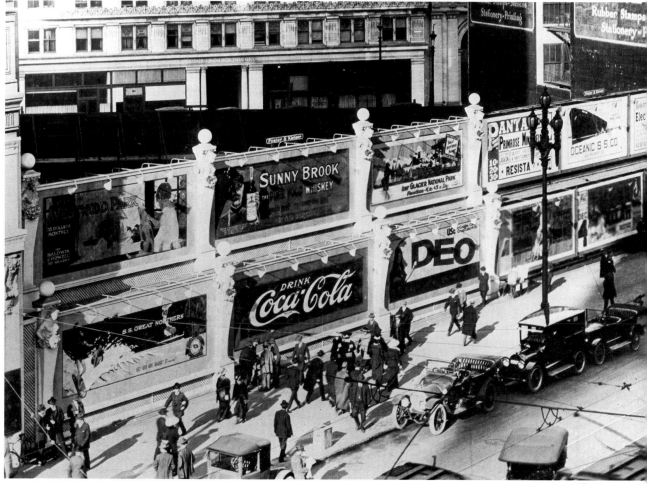

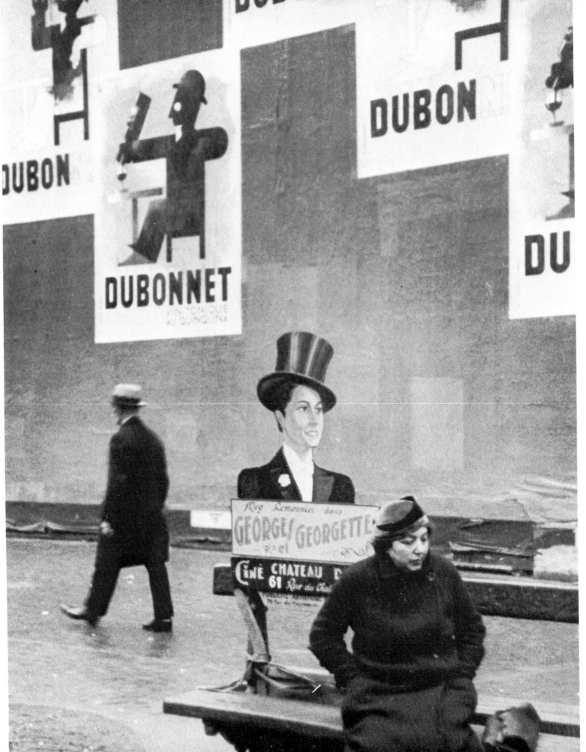

raised the speed limit from four to twelve miles per hour.

In the early 1900s, the volume of cars sold was very low and paid for only a small amount of promotion in the form of tours and endurance races. Mechanical reliability was the main thrust of the early ads. It had to be, since customers were wary of the first, not-very-effective engines. They had seen friends and relatives struggle to keep them in working order; the engines would even blow up on occasion.

In the first decade of the new century, a revolution in transportation was in full swing, changing the traveling habits of people living everywhere in the Western world. An intense connection between the automobile, auto travel and the outdoor poster was the natural outcome of a society in which individuals were becoming increasingly mobile. The outdoor ad had been waiting all along for the one product to come along that would change the world's habits, styles of living and advertising modes: the automobile.

Initially, billboards in Europe and the United States had found a ready market by catering to the bicycle trade, which viewed the posters while cycling by on their Sunday outings. Famous commercial artists like Beardsley and Parrish had already designed wonderful Art Nouveau ads showing bustled ladies and romantic young couples riding through parks. Soon auto ads took

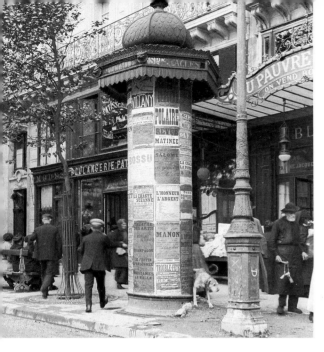

The advertising column, exemplified by this kiosk in Paris covered by ads and playbills, is common to most European countries but is only recently being introduced to the American urban landscape. Walls erected around construction sites were considered prime billposting locations. The British referred to these temporary wooden structures as "hoardings." Property owners collected fees from advertisers for the privilege of placing their posters in heavily trafficked areas.

famous ad campaign entitled "The Penalty of Leadership." The ad snobbishly declared that Cadillac continued to overcome any and all problems to remain the superior brand of automobile. The message conveyed was simple: pride in ownership overrode petty concerns about what lay under the hood.

Advertising by association continued to build on the premise that a product could be valued for the prestige it conferred. A family no longer bought a car for transportation alone. If the family was even modestly well off, the family members wanted a car with a certain image. Now you could be a person of quiet elegance in a

their cues from these highly sophisticated bike ads which had been so popular for years.

Despite the revolution in auto design, auto trips across continental United States were still difficult because of the unpaved, muddy, impassable condition of the roads which had not kept pace with technological advances in automobile production. Farmers earned good money pulling cars out of deep ruts with their teams of reliable tractor horses.

But things were changing. During the year 1900, two hundred thousand cars were manufactured in the United States alone. Gradually the ads for all these cars began to turn away from the technical aspects of the invention and to focus on the psychological implications of the relationship of car to owner. Advertisers took a new direction. Ads detailing the car's self-oiling bearings and hub brakes were gradually replaced with efforts to define the car's special personality: the image of the product became all-important.

Cadillac came out in 1915 with a now

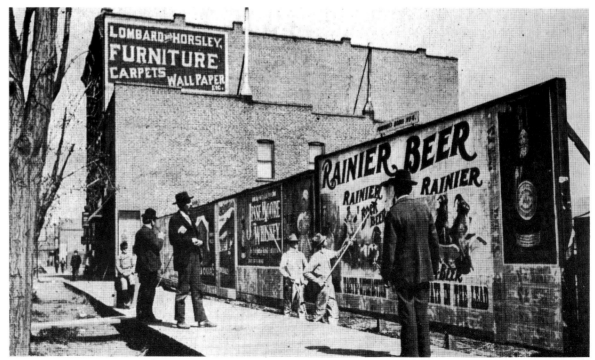

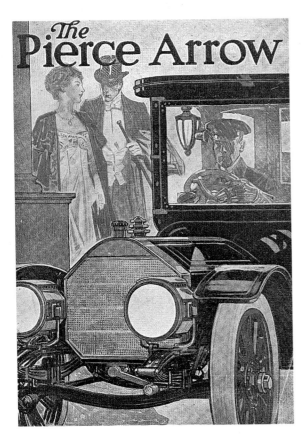

Pierce Arrow, or a member of the sporting set in a Templar or Stutz. Ads for roadsters showed dashing young couples with the wind in their hair, while a closed car would most likely have a reserved mother and child parked in front of their well-trimmed yard.

Advertisers had begun to learn that they could create markets where none had previously existed. Billboard images were lessons teaching the public what to want in the way of products.

By now the roadsides were well established as important places to advertise, especially for rubber companies like U.S. Rubber, Firestone and Goodyear, who had always known that drivers

Advertising was often designed on the premise that products could be sold by the associations created by juxtaposing symbolic elements in the ad. Here the Pierce Arrow automobile created its market by selling consumers an image of wealth, elegance and prestige.

going any distance would need to change punctured tires. But as tires grew more reliable, advertisements for Ford, Chevrolet, Carnation Milk, Wrigley's Gum, Coca Cola, and other manufacturer's products dotted the landscape clear across the United States.

At this point, large walls in the country side were covered with ads for Dr. So-and-So's Miracle Cures, or Mail Pouch Tobacco. Larger barns were even better—especially if they ran parallel to a road or railroad track. Grocery store walls were almost always rented for $5 or $10 per month to display local or national food products.

Billboard and sign technology was advancing on another and yet more sophisticated front. In New York City, the huge electric light "spectaculars," as they were called in the trade, had been growing in size and scope. The country's most complex and intricate signs, these electrical billboards had originated before the turn of the century. As early as 1891, the first one went up on the nine-story structure that occupied the site where the Flatiron Building now stands. The signs advertised Spencerian Pens and Sapolio, a household word in soap. By 1899, the coveted space went to advertise Manhattan Beach, with the glowing slogan "Swept by Ocean Breezes." Later, Continental Tobacco and Heinz 57 Varieties took over with a dazzling display of bulbs that were hooded with colored glass caps.

As road travel increased the billboard and automobile industries developed simultaneously, reflecting the needs of the newly mobile public.

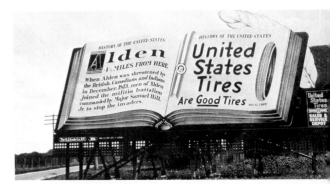

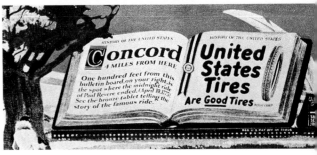

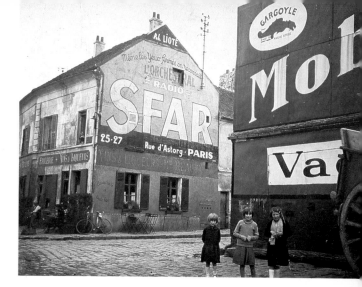

Large barns and walls along country roads and railroad tracks were used to advertise patent medicines and chewing tobacco to passing travelers.

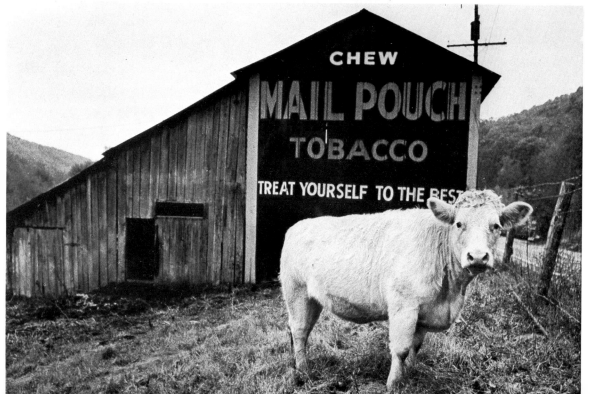

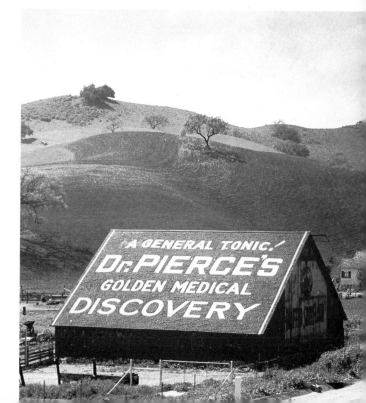

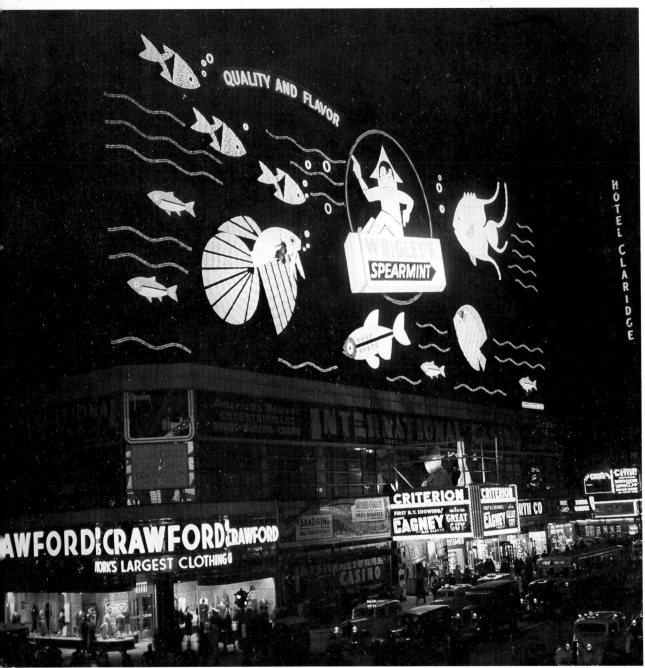

In 1917, this electrical light "spectacular" for Wrigley's chewing gum occupied an entire New York City block.

Other spectaculars —such as these on Times Square— have helped make the area the landmark that it is.

By 1905, the area known as The Great White Way in New York stretched from Herald Square to Forty-Seventh Street. No one could miss the electrical ads for the Cortecelli Kitten, the White Rock Nymph, and the Heatherbloom Petticoat Maid with their images running through a rain of lights.

From 1910 to 1914, a twenty-thousand light extravaganza put up by the Rice Electrical Display Company, showed a Roman chariot race on the side of the Normandie Hotel at Broadway and Thirty-Eighth Street. In 1917 the Wrigley Spearmint Company placed a wonderful ad of fish swimming across a black sea. There are family stories of immigrants standing for hours beneath the "spectaculars," marveling over American ingenuity.

In 1914, tension in Europe exploded into World War I. In 1917 when the United States joined the war with a declaration from President Woodrow Wilson, election posters from 1916 were still on the billboards. Wilson's campaign slogans read: "He Kept Us Out of War" and "War In The East, Peace In The West, Thank God for Wilson."

In Europe and in the U.S., the outbreak of the First World War introduced whole societies to the political importance of media influence. Newspapers and government advertising promoted enthusiasm for the war effort on an international scale. Suddenly, mass opinion gained a

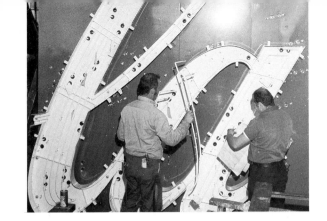

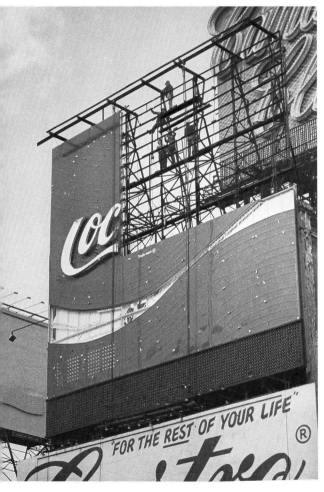

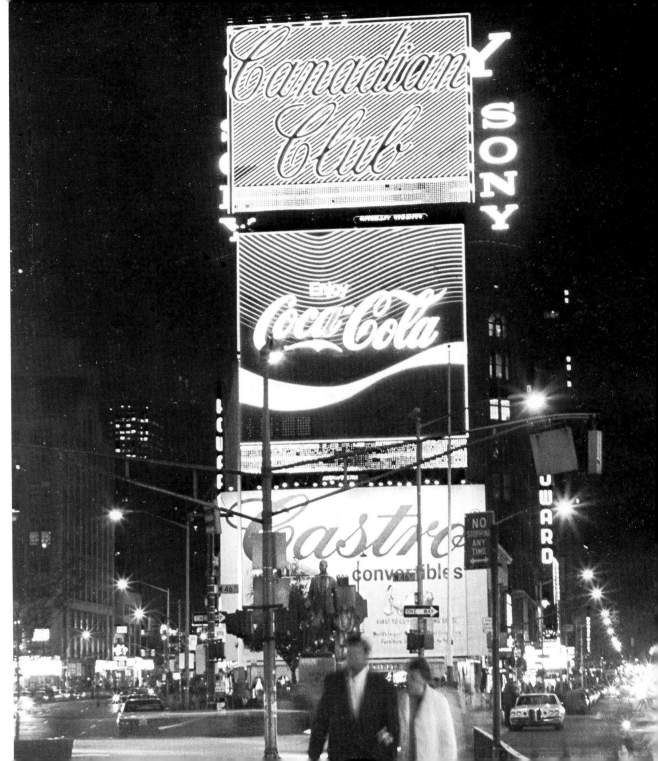

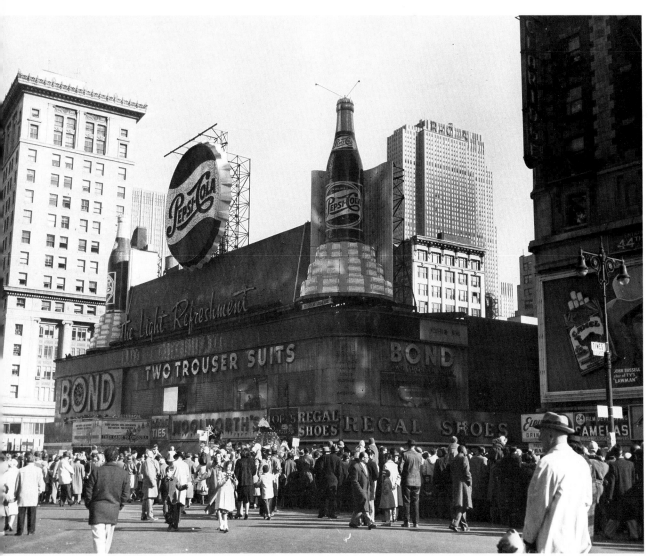

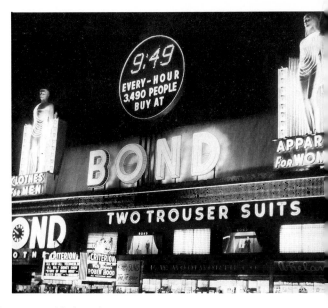

The more sophisticated spectaculars of the 1940s incorporated three-dimensional elements into their design. Bond Clothiers' display, featuring figures clad only in neon and reminiscent of Adam and Eve, eventually gave way to giant bottles of Pepsi.

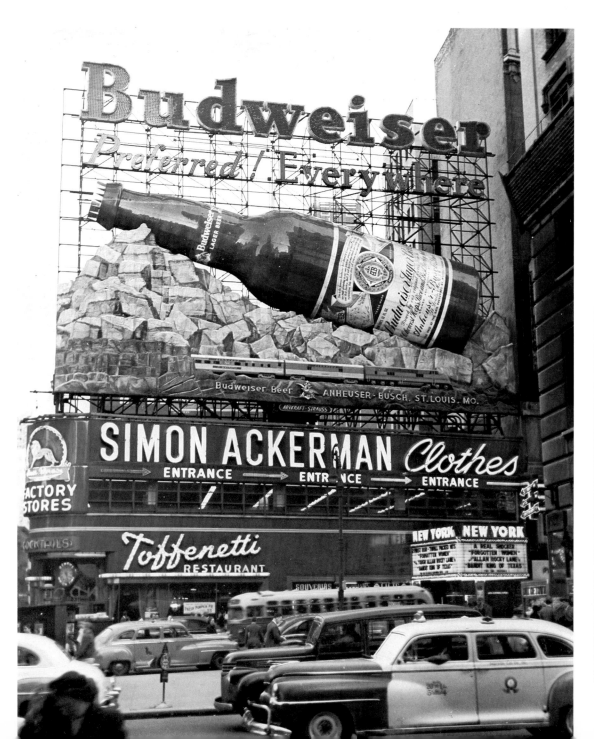

An oversized beer bottle rests on a bed of neon ice, and Kleenex tissues feature their new pop-up convenience on these New York spectaculars. Large crowds would often gather to view these unique electrical and sculptural displays.

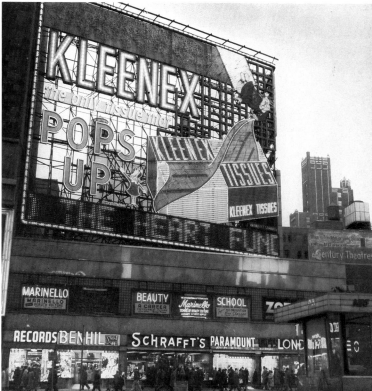

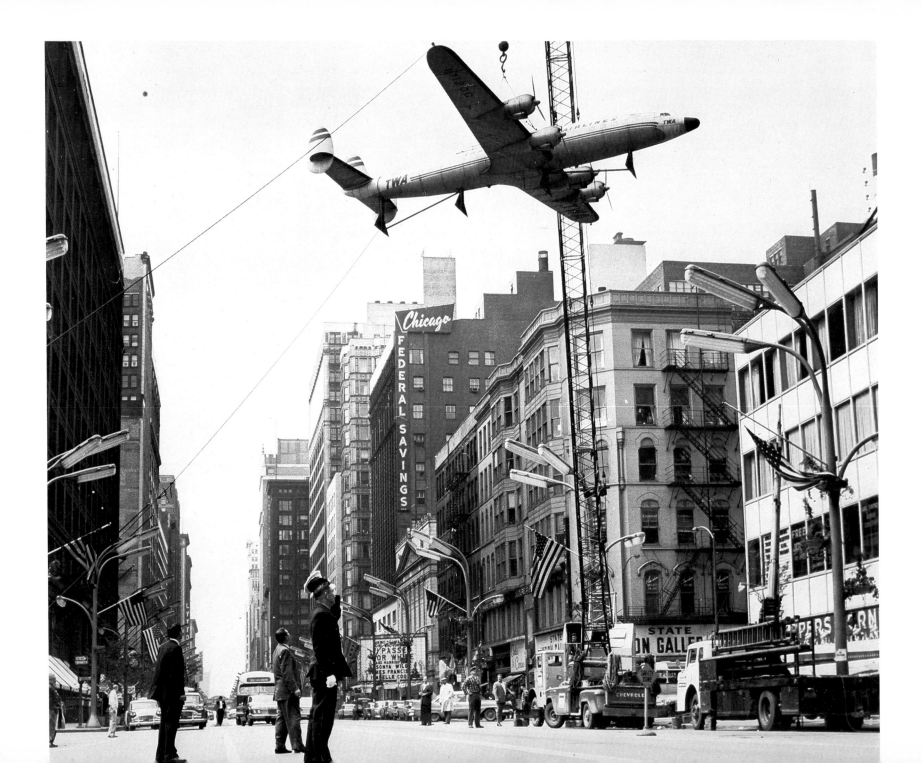

Curious pedestrians gaze up at a
Trans-World Airlines advertising
display that has been hoisted
above a Chicago street.

In New York an illuminated model of the Statue of Liberty is used
to arouse enthusiasm for a World War II loan campaign (left).
In 1925, the Eiffel Tower, according to the Guinness Book of
Records, became the world's largest outdoor advertisement
when it displayed the name of the French automaker "Citroen"
in a large electrical illumination.

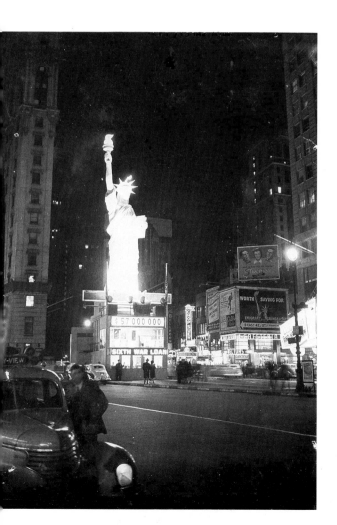

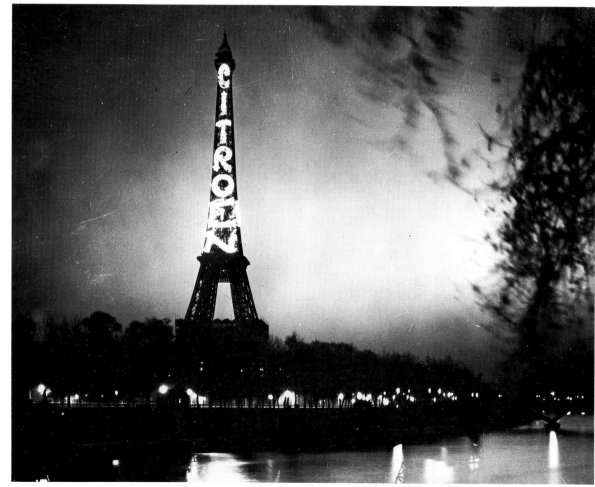

new significance, and in the U.S, mass opinion started favoring the war.

The fighting forced social change for everyone; victory gardens, rationing of luxury items, the departure of fathers and sons for overseas. New jobs opened up for women, especially war-related industrial jobs previously held by men. Trade unions gained more power and wages rose to match the spurt in wartime goods and services. While the conflict created monumental hardships for the countries involved, and, indeed, for the entire world, it greatly supported economic growth and accelerated advances in industrial technology.

Advertising in time of war usually takes a serious tone, appealing to familiar human strengths, rather than to superficial frivolity. World War I was called "The War to End All Wars;" in order to be successful, advertising reflected this seriousness of purpose. Photography was almost never used in ads; instead, family life was represented by illustrations which had the capacity to idealize.

The realistic, objective portrayal of a subject or product in photographs was at first considered undesirable by advertisers and ideologues. They had grown accustomed to showing their products through the idealization of illustrations. Photography in its infancy was limited to black and white imagery, which was not bold enough to catch the

eye of a passerby when compared to the bright colors of the other graphic art processes.

Throughout the early twentieth century, but only very slowly, photography was integrated into poster and advertising campaigns. A politician running for public office might, for example, distribute bills with his portrait in order to familiarize voters with his face. Advertisers, too, soon realized that a photographic image could be manipulated in order to convey a selective "reality." A product might be photographed in black and white, and then retouched and airbrushed with color, so that the resulting image contained both realistic and hyperbolic qualities. Since by now

the public had come to accept photographic images as being unquestionably *real*, photography became a powerful tool in the hands of advertisers and propagandists.

During the First World War, the carefree attitude of spontaneity and creativity that had developed since the 1900s disappeared, and advertising seemed to take a step backward. The industry became more cautious, and the posters and billboards featured time-tested images of home and family. The social climate was one of fear and tension, and this primary point was driven home in copy that was briefer than that used in the more prosy advertisements of the pre-

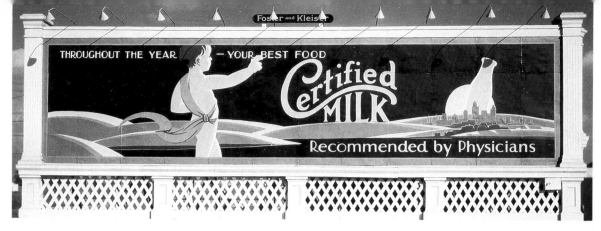

vious century. There was a definite move toward conservatism, culturally and politically.

During the fragile peace that followed World War I, the United States prospered. The doctrine of isolationism encouraged people to ignore the worsening economic and political situation in Europe. In 1921 the United States even withdrew from the United Nations, putting up high protective tariffs on imports and pushing free trade at home. Under the great boom of the "New Era," the United States stepped up productivity, epitomized by the commercial advances of Ford

Fine art trends, such as Art Deco, influence billboard design as evidenced in these decorative advertising campaigns. Women were thin and had elongated features. Products were frequently rendered in stylized line and silhouette.

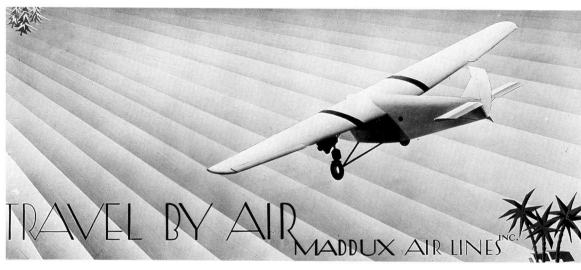

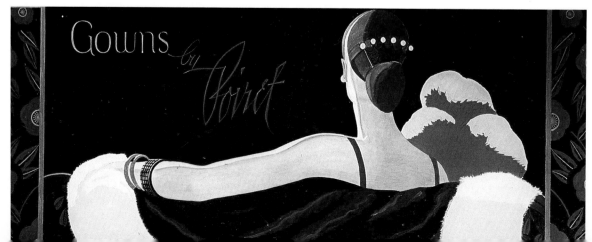

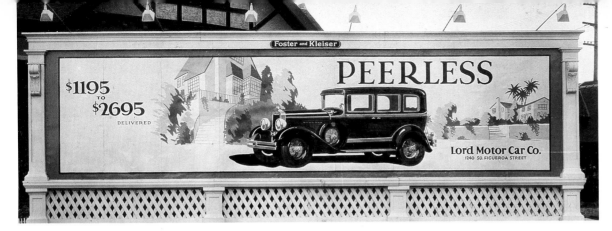

As the automobile became a fixture in American society, advertisers looked for new ways to attract consumer interest. While this Peerless ad represents the classic approach, Ford takes a more whimsical attitude in communicating the capabilities of its V-8 model.

Motors. For the rest of the world, however, the 1920s was a period of unrelieved bleakness.

By the year 1920, there were six million cars in the United States, an amazing number considering the dismal state of the roads, which were not nearly as good as those in parts of Europe. The distances to be traveled were huge, considering the newness of the cars and the poor roads. Many people saw the upsurge in the production of automobiles as part of an overall trend that would keep the United States in the forefront of world markets indefinitely.

By the year 1920 (and up to the Great Depression), advertisers had the simple task of suggesting ways for a war-weary public to spend its money. The market appealed to the nouveau riche and the expanding middle class with illustrated ad campaigns. The images seemed to imply that all segments of the American public were equally well off. The roly-poly Gibson Girl had lost favor: a more sophisticated woman with elongated features represented the popular concept of elegance. An ad featuring the country club set enjoying dinner among marble columns spoke to the middle class about how to live like high society.

Advertising had come to promote a certain snobbery, and people were encouraged to buy, not because they needed things, but because their status in life depended on owning certain

luxury items. The period was flamboyant and ostentatious; the advertising copy was designed to flatter the prospective purchaser. Stylized elements of design were introduced into billboard ads: mundane typefaces disappeared and were replaced by elaborate lettering and borders. Characters—especially women—in ad illustrations wore more elaborate costumes. The movement was away from the everyday and towards the more pretentious.

Up until the end of the nineteenth century, most people considered it shameful to be in debt,

but by 1920 the American car and contemporary advertising had done a great deal to destroy this deep-seated attitude. Thrift, once the pinnacle of virtue, was being replaced by an acceptance of installment buying. Advertisers had worked hard to manipulate the public into wanting and expecting things they could not possibly pay for with cash—a situation not unlike today's.

As early as 1912, some car dealers offered cars on credit. In 1916, the Maxwell Company sold its product with the ad campaign "Pay As You Ride!" By 1927, the American consumer

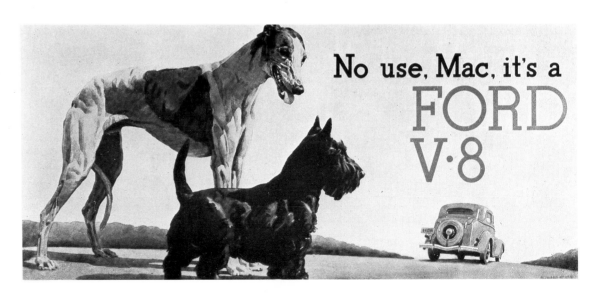

No use, Mac, it's a FORD V·8

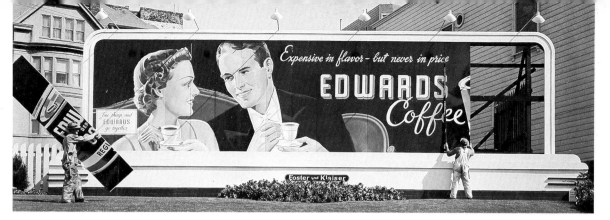

Distinguished and well-to-do couples were associated with products that were "expensive in flavor—but never in price." The consumer, by identifying upper class symbols with a given product, was led to believe the products were of superior quality. Technological advances in billboard construction and installation, including improved methods of hand-painting, removable plywood panels and a curved moulding frame—gave billboards a modern look. The lattice-work base was replaced by one featuring a sleeker radial design.

had gone four billion dollars into debt, and was ready to spend more. Just in time, Henry Ford announced a replacement for the new Model T—the Model A. Despite Ford's famous remark to the effect that any color for his cars was suitable so long as it was black, the new automobiles even came in colors. The Model A's had appeal, and Ford spent an unparalleled $1,500,000 in advertising to insure that this appeal was appreciated by the buying public. In Detroit, Cleveland and Chi-cago, the lines of waiting consumers circled block after block around the dealerships. Public schools were closed so that the youngsters might have an early peek at the new model.

The roads were soon crowded with many models of cars. The family car might be a Stude-baker, Nash, Essex, Peerless, Pontiac, Overland, Willys, Reo, or Dodge. The more expensive Cadil-lac, Packard or Pierce-Arrow was considered nice to have in the driveway as a prestige car. On the

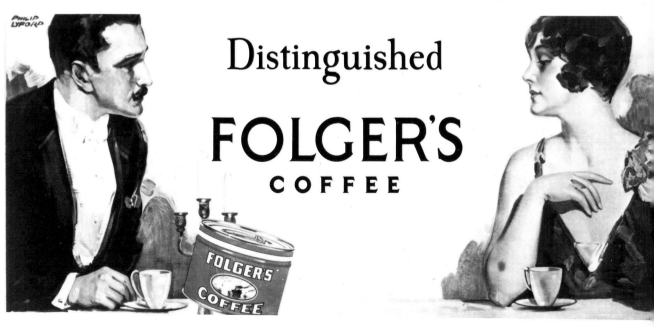

weekend outings you might drive a Jordan, Kissel, Aubrun, Dusenburg, Marmon, Templar, or Stuz.

During the 1920s, many families began to travel with their children, and even take along their pets, on cross-country holidays. The speed limit was at least thirty-five miles per hour, and the roadside cabin, which rented for $2 or $3 a night, was becoming popular.

By the late twenties, the roads were much better and tires had a far longer life expectancy. Fords and Chevys could travel at fifty miles per hour, and vacationers didn't have to carry ropes and axes to traverse difficult terrain. This was the era of bootleg whiskey, sports clothes and the flapper; young people out for a good time took to the roads in large numbers, just as families did.

Advertising got its biggest boost after the war from the influx of highly promotable products. Cigarettes had previously been seen as something undesirable, people who smoked as somewhat degenerate. But the war changed the popular attitude. Young soldiers returned home with the smoking habit, and the public made a crucial switch: smoking became sophisticated.

Throughout the twenties and thirties Camel, Lucky Strike and Chesterfield waged an advertising battle. Lucky Strike spent a quarter of a million dollars on ad campaigns bearing such slogans as "Nature In The Raw Is Seldom Mild," and "Reach For A Lucky Instead Of A Sweet."

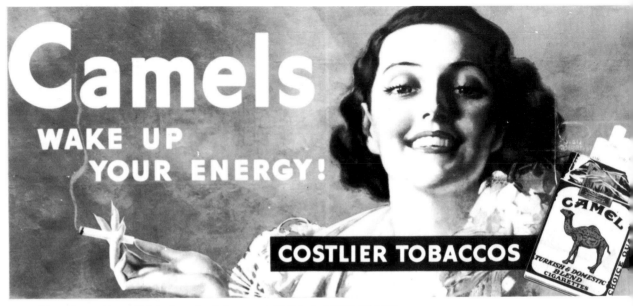

Cigarette smoking, which had previously been considered an undesirable habit, gained wider acceptance after World War I through advertisements showing youthful models in romantic poses. Advertisers also attacked the notion that smoking was only for men by appealing to women's growing sense of independence.

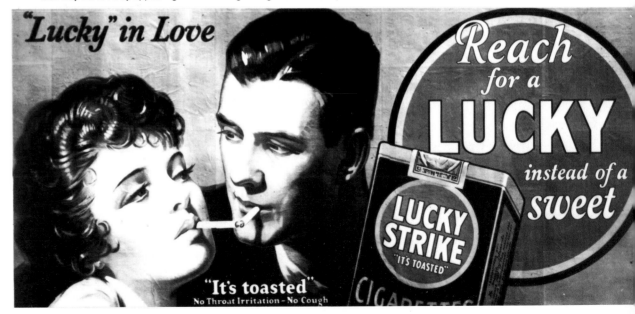

In 1926 Chesterfield expanded its market by promoting the smoking habit among women. Ads pictured women smoking in public, and actresses and female celebrities saying "Blow Some My Way." The expectations were already less strict for women: for college girls and society matrons, who could now drink, wear short skirts and vote, smoking became one more declaration of independence.

In addition to tobacco, the advertisers were also pushing the new products of the technological era including radios, phonographs, stoves and refrigerators which had better designs. Many brands of the same item flooded the market and forced more intensive advertising campaigns in competition for sales.

Advertisers used billboards more extensively than ever during the late 1920s. Entire campaigns were devised with a prescribed number of billboard "showings," which were calculated to increase a company's sales by a certain percentage. A new organization called Outdoor Advertising Incorporated was created to help advertisers develop more effective national billboard campaigns. For the first time, advertisers could sell their product from coast to coast, yet still have their outdoor ads tailored to the particular area or market where they would be shown.

Just as certain decades have their distinct idiom or style, recognizable at a glance,

subcultures do also. Obviously, the likes and dislikes of different ethnic groups are divergent enough that the same image will not sell equally well in every area. Certain pictures or colloquial ad copy captures the imaginations of Southerners and Midwesterners, using words and pictures that urbane New Yorkers, for example, might find offensively corny. Cigarette and liquor advertisers prefer using black models on ads going up in inner-city neighborhoods, and they can demonstrate that doing so boosts sales. In Europe, the billboards in every country boast models who display the recognizable physical characteristics of the local nationality. This has always been the

billboard's strongest selling point: the ability to reach out and appeal to diverse ethnic and cultural groups within their own neighborhoods.

Outdoor posters and billboards are the only two mediums where the advertiser allows the consumers to circulate around the message, rather than circulate the message to the consumers. This permits a product to be seen by every potential customer from every economic level unless he stays home and never drives. Billboards are constant reminders. We see them before we enter a supermarket and remember to purchase cling peaches. To hungry families on long car trips they are a signal that McDonald's

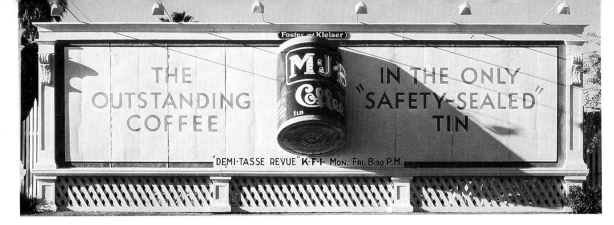

As competition among similar products increased, advertisers began to rely heavily on trademarks and logos to set their product apart. Container design, shown in this three dimensional coffee canister, was also important for product identification. With increased world trade, new products appeared and foreign imagery was used to lend an exotic appeal.

hamburgers are just around the bend. The simplicity that must be part of a good ad—one that can be read in only a few seconds—is what makes it memorable and gives it power.

After World War I, advertising became more of an exact science, with more extensive ventures into research and statistical analyses. The advertising agency became an increasingly significant part of the advertising armature.

Technology was advanced enough that it became feasible for the businessman to sell an item individually wrapped, rather than in bulk, as had been the previous custom. The public quickly grew enthusiastic about the idea of not having to take its crackers out of an open barrel (full of many things that might not be crackers) and about being given a neat little box or tin to take home instead.

With individual packages, advertisers needed a logo or word to identify them, one they could print on the box and that the public would remember. The first trademarks were extremely complex little drawings with the quality of painted miniatures. They usually showed people enjoying the product, or mythical scales weighing it out in all its purity. Folk symbols were very popular at first: pictures of pilgrims, Indian chiefs, and busy housekeepers appeared often. Aunt Jemima has outlived generations of pancake-eating children, and the Planter's Peanutman,

complete with top hat and walking stick, lives on.

Initially, advertisers thought that, in order to market an item, it was sufficient to put forth a rational argument as to why someone should buy it. But all this changed over time. By the mid-twenties, ad agencies realized that an easier and more lucrative approach was through good copy, aimed at the emotions of unwary consumers. Copywriters appealed to the fears, vanities and guilts of the buying public to sell everything

from toothpaste to deodorants to tombstones. The marketing man and the copywriter enjoyed a hey-day, from the twenties through the forties, that earned them reputations for quick wit, high salaries, nervous breakdowns, and early retirements. And it was the ad agencies that finally came up with the winning solutions to memorable, readable billboard messages in the United States and abroad.

In addition, writers learned to tailor ad

copy to different products and particular buyers. World markets opened up and many ads reflected trade with foreign countries—especially through the influx of Middle Eastern imagery. We can still see the reminder of this influence, represented by the enduring Camel cigarette pack.

Advertisers began consciously using color to manipulate the emotions of buyers. The warm, vibrant colors—reds, yellows, oranges —generated a sense of excitement and enthusiasm in the onlooker. Red has always been considered a passionate color, carrying with it associations of violence and sexuality; and its companion hues, yellow and orange, convey a similar immediacy. The cool blues and greens, on the other hand, are calming, soft and refreshing to the viewer. These colors have often been used in cigarette ads to associate smoking with fresh air, good health and the great outdoors.

A good campaign always meant twice the return on each dollar spent on promotion. Simplicity of message and idea on the billboard were essential for the passenger in a car, moving at normal speed on a street or highway, to assimilate the image in approximately five seconds or less. The large dimensions of the billboard helped to capture everyone's attention—nowhere else does an advertiser get to present his product on such a grand scale. But there is always competition from other elements in the landscape—

Despite the naïveté of this early ad, Coca Cola has successfully used its logo and bottle design to create a product that is immediately recognizable worldwide.

buildings, neon lights, other billboards—so that every inch of the poster or board had to be used effectively.

The ad campaigns of the late twenties were at last on the pulse of their billboard markets. They showed stylized, airbrushed drawings of the product and what it offered the buyer, with a word message to highlight its strongest appeal. The package was often shown with the name prominently displayed. The billboard itself

was nicely framed and matted with a wooden moulding as trim.

In fact, with all of this marketing and buying, economic activity in the United States continued on the upswing until the stock market crash of 1929. In October of that fateful year, continual speculation in the market bottomed out. Presidents Harding, Coolidge and Hoover—as well as the United States banking establishment—had bolstered the market year after year,

Depression-era advertising often ignored the prevailing economic situation and continued to sell the American dream of unending prosperity. In the cities department store ads gave no hint of the economic crisis, but a rural roadside store covered with small, unkept signs more accurately reflects the mood of the times.

but this time nothing could stop the downward trend.

As United States loans were cut internationally, country after country felt the effects of the 1929 crash. The currency systems of the world collapsed; the mark and shilling in Germany and Austria were all but destroyed; Britain went off the gold standard after a run on the London gold market. France held out a bit longer, but by 1932 was in the throes of her own depression. The story was the same everywhere.

While the Depression was a time of sorrow and suffering for most people, it was a superficially happy time in advertising art and popular culture. Manufacturers knew that the last thing the public wanted to see was discouraging images in advertising. Most advertisers chose to ignore the poverty, breadlines and joblessness of the era. Instead, they showed nicely dressed women having a wonderful time, accompanied by well-mannered youngsters.

And so—just like Hollywood films of the period—advertising gave the public an avenue for escape into a beautiful, rich, problem-free world. Advertisers understood the people's need for entertainment to take their minds off of their troubles and their wish to see the much longed-for good life portrayed in movies and billboards. The illustrations were very colorful in Depression-era billboards, evincing an almost

childlike spontaneity. Photography was beginning to take away part of the ad business from illustration, and the illustrations that remained became larger and used less detail.

During the lean years of the thirties, advertising in general took on a disturbing moodiness: it seemed to become aggressive, even ugly, in tone. A viewer might have noticed a tired quality about the illustrations that remained in the ad market, even though airbrushing techniques gave ads a realism not seen before.

Ad people seemed to think the photograph imparted a quality of reliability, and since people were now trying to save goods rather than buying new ones, that was a desirable impression to create. General Motors, in fact, came out with a campaign based on the intense reliability of their cars over the competition.

It was during the Depression and the early 1930s that an unusual national billboard campaign was born in the midwestern United States outside of Minneapolis, Minnesota. Tiny wooden signs measuring one by three feet were placed at one-hundred-foot intervals, in sets of six, expounding the wonders of a brushless shaving cream called Burma Shave. The traditional shaving brush was still popular in those days, but it was messy when dipped into the shaving cream and it was also hard to store and carry. So the Burma (because the oils came from

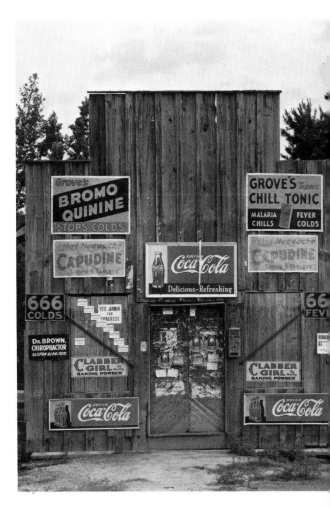

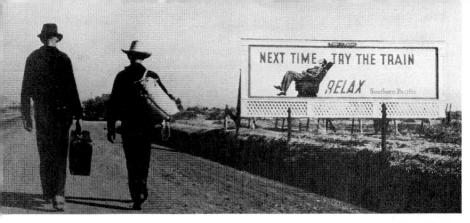

During the Depression, economic reality was not reflected in the idealized billboard art, lending an ironic edge to these photographs. Uprooted migrant farmers, unable to afford transportation, walk past a billboard featuring the comforts of train travel (left). Flood victims line up for aid beneath a billboard of the "typical" American family, in this classic photograph by Margaret Bourke-White (below).

there) Vita Company launched a poetic promotion that took its signs throughout the country. That campaign still lives in popular memory.

Depression advertising, maintained in an atmosphere of economic grimness, had very little humor in it—buying and selling were serious business. Most of the ad copy took the form of the lapel-grabbing, morally earnest hardsell. Times were very hard, and in the beginning, the Burma Shave Company had to give away "jars on approval" in the hopes that the door-to-door salesman could collect some money and a happy new customer when he returned. Often the empty jar was handed back with only a thank you, so a new approach seemed in order. The little Burma Shave signs went up, slowly but surely, state by state, and became well-known landmarks for auto travelers within just a few years. The company's profits soared.

Who could remain uninterested or unamused for long, when greeted on the road by: *He Played/The Sax/Had No B.O./But His Whiskers Scratched/So She Let Him Go/Burma Shave*. The little signs, jolliness and lack of pretension won everyone over. The public was captivated, having never been spoken to by an ad in quite this way. *Does Your Husband/Misbehave/Grunt and Grumble/Rant And Rave/Shoot The Brute/Some Burma Shave*.

The six small signs took approximately

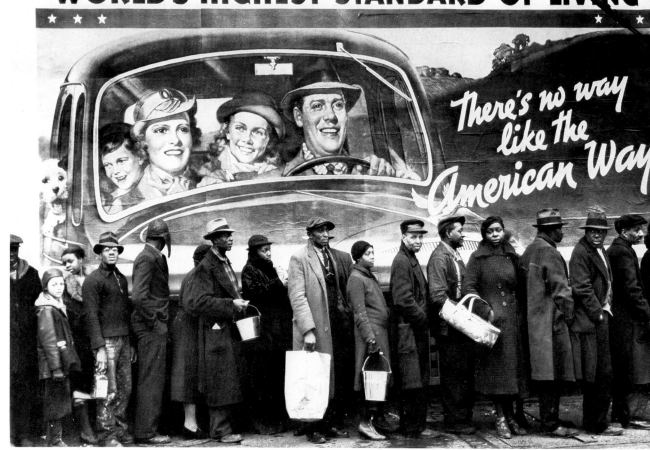

WORLD'S HIGHEST STANDARD OF LIVING

There's no way like the American Way

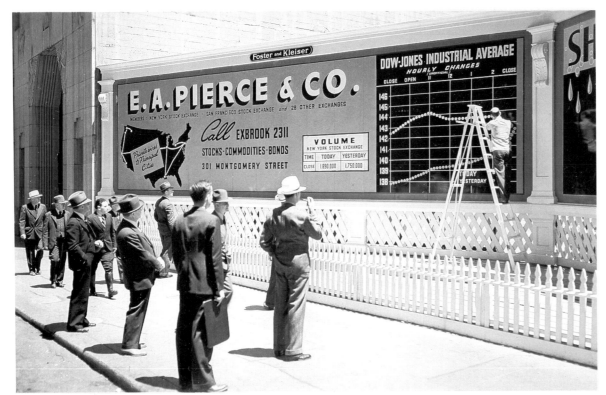

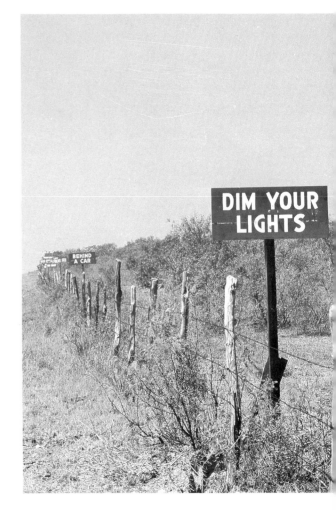

A billboard in San Francisco's financial district kept businessmen up-to-date with the shifting economic situation. The first form of sequential advertising, the Burma Shave signs, spoke to the public in a new way with both humor and wit. The small signs, installed at the roadside in sets of six, took approximately eighteen seconds to read when the car was traveling at a speed of thirty-five miles per hour.

eighteen seconds to read at a speed of thirty-five miles per hour, giving more viewing time to a prospective client than either newspapers or magazines could then deliver. The spacing added a special cadence to the reading as well as an element of suspense: *The Bearded Lady/Tried A Jar/She's Now A Famous/Movie Star/Burma Shave.*

During the nearly forty years of the Burma Shave sign campaign, from 1925 to 1963, almost seven thousand sets or forty thousand individual tiny signs dotted the roads from Maine to Texas. And the company rose, from the days of handing out jars on approval to a three-million-dollar, coast-to-coast business. And in those days, that was very good business, indeed.

The Burma Shave sign became such a national institution that the United States Navy once asked if they might put up three sets of signs in the Antarctic. It seems there was a particularly long stretch of submarine duty where the men didn't see land for several months, so, at a rather famous crossing, through a pass of treacherous ice, there, plain as day, sitting in the snow, were the Burma Shave signs: *The Whale/Put Jonah/ Down The Hatch/But Coughed/Him Up/Because He Scratched.* When the old signs came down in 1963, even the farmers who owned the land on which they stood were reluctant to let them go. Today Burma Shave signs that disappeared before the company could take them down turn up in antique stores nationwide, and in 1964 a set of signs was presented to the Smithsonian Museum: *Shaving Brushes/You'll Soon*

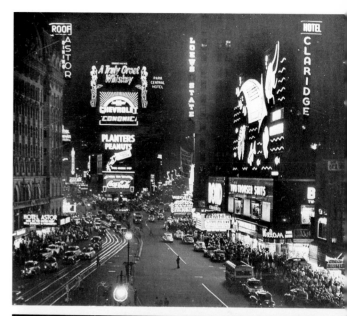

Colorful light displays in metropolitan areas are signs of a culture's vitality. Without them, as in these photographs showing a war-time black-out in New York, cities seem bleak and lifeless.

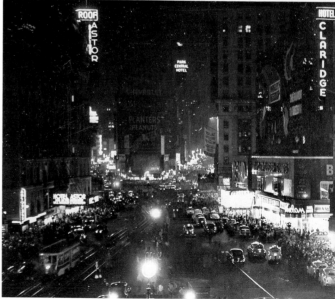

See 'Em/ On The Shelf/In Some Museum.

The 1930s were a period of anger and confusion and economic uncertainty. Between 1933 and 1941, at least 10 percent of the work force in the United States was unemployed. The worst year of the Depression for Americans was probably 1932, when all of the enthusiasm surrounding President Roosevelt's New Deal led to nothing but increased unemployment. The poor had taken heart with Roosevelt's pledges, hopes were high that the United States would soon be able to contribute to world markets. Americans had learned to adapt to economic hardships, but they were tired of going without, and were increasingly alienated by such campaign promises as "…the only thing we have to fear is fear itself," or "I pledge you, I pledge myself, to a new deal for the American people."

The income of the average consumer was still low, but food and rents were on a par with wages. Public buildings were being decorated with murals by artists working under Federal programs, and public dances were held with music furnished by the Federal Relief Administration. This was the age of prohibition, speakeasies, the jitterbug, and swing bands.

Advertising was left somewhere in limbo during the early thirties. Any remaining stylization had been removed from billboards. The style consisted mostly of plain photographs showing the product. An overall attitude of aloofness, even coldness, was apparent in the majority of billboard campaigns. And there was no advantage to be gained by aiming billboard advertising at the well-to-do: the pre-Depression nouveau riche had lost most of its money and the bejeweled ladies were once again struggling homemakers. The elegant images disappeared. It was difficult enough to push more basic purchases, like refrigerators, on people wondering where their next meal was coming from.

The mid-1930s saw a trend toward the use of photography in advertising that has never stopped. Pure realism through illustration and photographs seemed to be the style favored by most art directors as the surest way to sell the product. Although in 1937 the United States was nearing recession again, there came a brief interlude, during the years 1935 and 1936, when the country tried to regain its economic balance and to forget the Depression had ever occurred. No one was going off to war; young men and women could think about college. Most of the unemployed had been able to find jobs, and if there were no jobs available, families could depend on relief until one came along.

As if to counterbalance the intense realism in ad imagery, a trend toward advertising in comic strips emerged at the same time. The comic-strip format was taken directly out of the

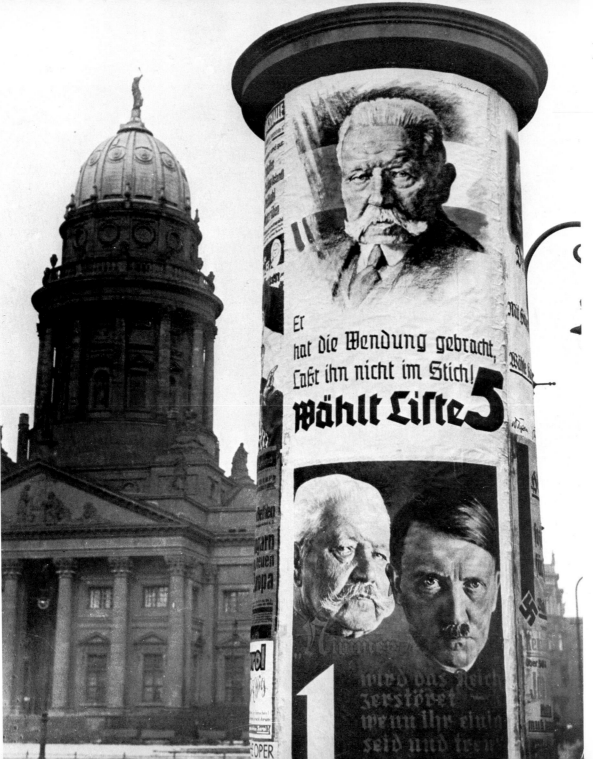

newspapers, and served as a story-telling ad in sequence form. These ads were not particularly eyecatching; if anything, they were childlike and unsophisticated. But they mirrored the retrenched feeling of the nation.

The 1937 recession put a halt to most of the rebuilding that had gone on under the New Deal. Roosevelt had tackled the country's problems with unbounded energy, even repealing Prohibition in 1933 with his statement, "I think this would be a good time for a beer."

Some of the best, most realistic advertising art was created during the years 1940 through 1945. The new war in Europe changed the popular vision of life. For the first time the public wholeheartedly embraced total realism, the depiction of life as it really was, through pictorial, Norman-Rockwell style, classical illustration and straightforward photography. This was a large step for the public to take, considering that they had been manipulated in an idealized direction for so long.

The Depression hung on in Europe almost up to World War II. Throughout this period, the world economy was in ruins, each country trying desperately to regain its longlost prosperity. Great Britain, which had been locked into a general strike of organized labor starting in 1926, had by 1929, almost regained her feet, only to be bowled over again by the Wall Street crash and

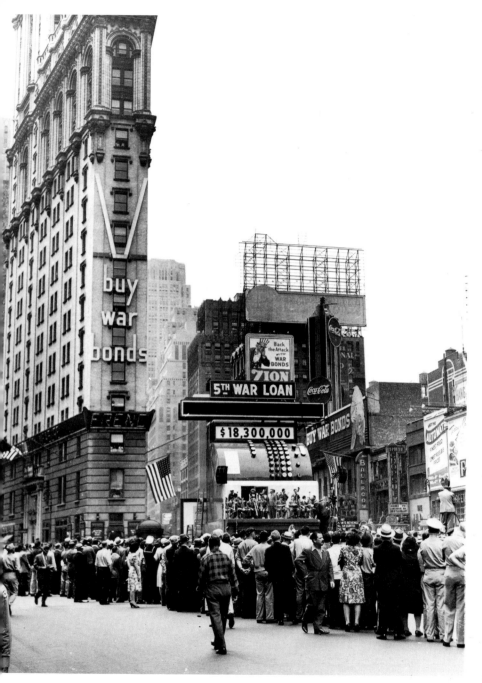

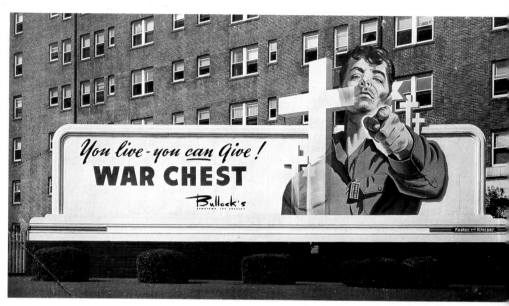

Advertisers were given tax credit for promoting the war effort along with their products. Children, cartoon characters, and promises of new technology for the future were used in advertisements to help sell war bonds.

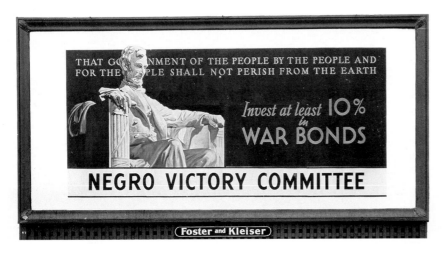

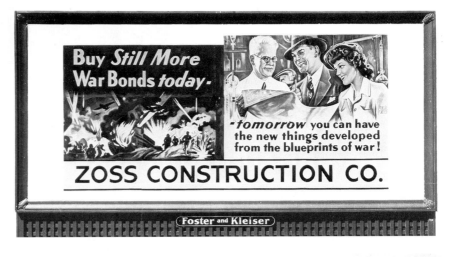

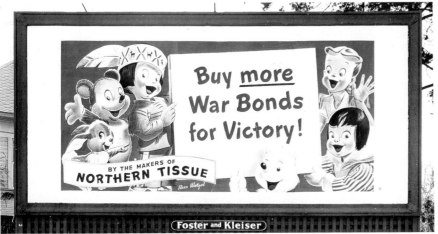

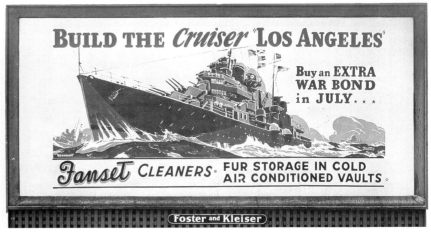

had spent most of the 1930s recovering economically.

In 1935, China experienced internal conflict between the rising Red Army and the Nationalists. Forced into the Long March, a 6,000 mile trek across their homeland, the Red Army won political support through the use of hand-carried banners and posters. As with the international tradition of circus advertising, scouts went ahead and carried bills into towns announcing the troops' arrival, and calling on the people to organize and follow them.

China has never displayed many colorful advertisements in its streets or villages; the goals of the Chinese Communist Party do not lend themselves to the commercial forms popular in the West. Instead, the walls are often decorated with huge portraits of popular political figures, or with calligraphy giving public information. The Chinese use images representative not of individualistic concerns and comforts, but of collectively oriented interests. To this day, the format of Chinese public messages recalls the naive, simplistic, melodramatic, and highly stylized quality of Western advertising at the turn of the century.

The Chinese political banners and posters are static by Western standards. They portray a heavy, somewhat grandiose style of Social Realism. Workers with their arms raised in protest unite in the fields against angry red skies.

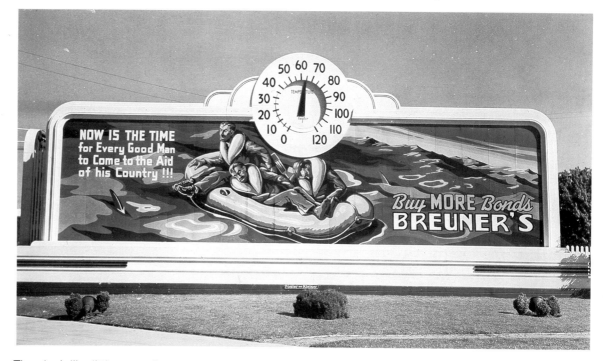

Multi-functional billboards, like this one featuring a temperature gauge, offered practical information to help draw attention to the message.

NOW IS THE TIME for Every Good Man to Come to the Aid of his Country !!!

Buy MORE Bonds BREUNER'S

They look like little more than pure propaganda to outside eyes, but to the Chinese they have always been an important medium for news. Without the benefit of much in the way of radio, telephone or television, the billboard was as important to Chinese modern history as more technologically sophisticated media in the West.

In 1940 the Japanese made a pact with Germany, which in effect gave Europe to Germany and the Far East to Japan, and the alliance guaranteed mutual aid if either was attacked. As Japan escalated her expansion, a climax was reached on December 7, 1941, when the Japanese attacked Pearl Harbor, bringing the United States into the Second World War.

By 1943 the majority of the world's adver-

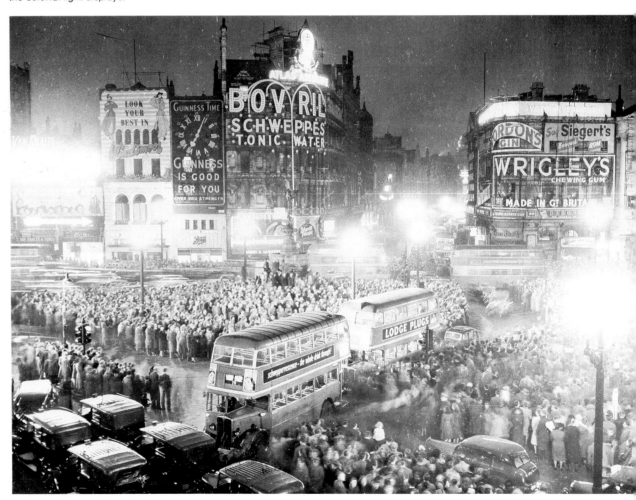

People jammed into London's Picadilly Circus to celebrate the end of the war and the return of the colorful light displays.

tising was created as propaganda. All nations had their own brand of media manipulation. Billboards were an omnipresent reminder of every government's expectations for its citizens, a political medium for a government's wish to influence popular thought and feeling.

Germany was one of the first countries to realize the political effectiveness of sweeping billboard campaigns. The state publishing house, Eher Verlag, along with a monumental deluge of radio, poster and billboard propaganda, became parts of a shrewd and influential program of public persuasion. By 1933 all printed communication, broadcasting, films, theatre, art and music, were under the control of the Ministry for Popular Enlightenment and Propaganda.

The inhumanities of war cannot easily be treated with the superficiality of most advertising. Unlike the happy-go-lucky approach towards billboards of the Depression that ignored the reality of suffering, the Second World War was depicted harshly. The public absorbed the most explicit war related campaigns. Soldiers were shown dying, or pointing out that they were "over there for you." An advertising style that manipulated basic emotions was accepted and used until the end of the war. Fear was frequently evoked: fear about the loss of one's life, culture, home, or children. Patriotism pushed the public to back the war effort. Ads were either intensely serious or

In Paris, the installation of the Moulin Rouge sign marked the return to peacetime concerns and entertainment.

ridiculously slapstick, as a reaction to the feeling of impending doom. Emotions were intense, and large billboards in the United States and Europe cried out for patriotism. In every nation heavily involved in the war, advertising went through a period glorifying "toughness," showing each people's self reliance. Even in the selling of baby food, tots were shown with stern expressions and military caps. Every product was somehow rougher and tougher than the next, and able to outlast all others.

The end of the war came about as a result of the nuclear attack on Japan by the United States. The end came suddenly for Europe; many nations had had no chance to convert from war to peacetime industrial production. Under the impact of worldwide economic hardship following the war, the United States assumed the role of world leader in helping to rebuild a stable economy.

The post-war reconstruction years were ones of optimism and a radical vision in many countries. In England, Churchill was defeated, and the Conservatives were replaced by the more liberal Labour Party, which advocated more programs of social welfare.

Western Europe, after centuries of bloody partisan struggles, began enjoying a new-found unity, the end result of efforts on the part of the Common Market and NATO to break down the old

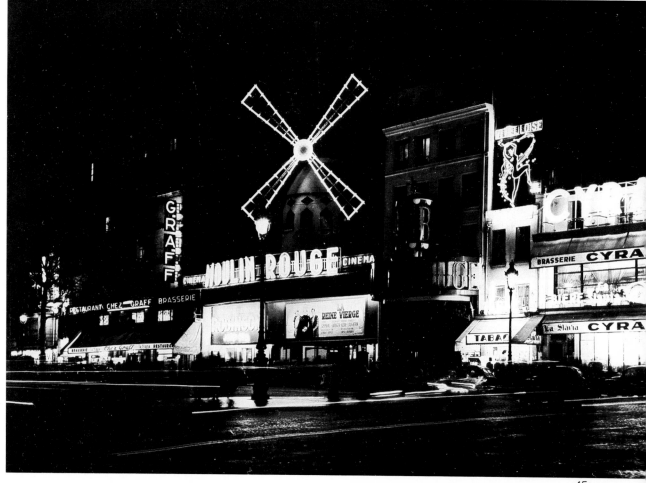

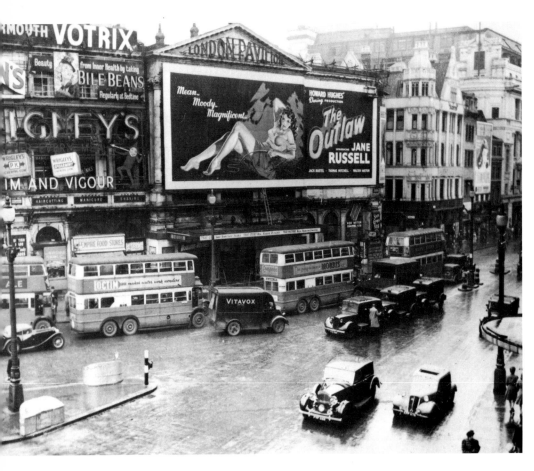

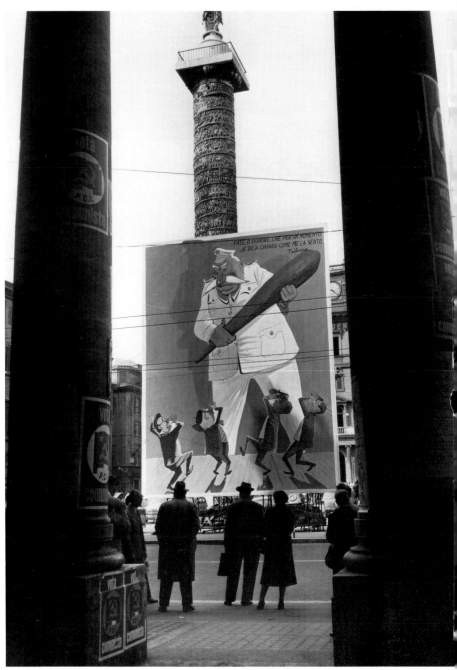

economic boundaries existing before the war. Political integration brought a flood of new products to the once independent and nationalistic European countries. Even the strict European system of workers, middle class professionals, and the rich and titled began to ease and disappear, and opportunities increased for individual entrepreneurs. People were more and more frequently the possessors of consumer goods once considered unthinkable luxuries: refrigerators, cars, and, eventually, television sets.

Advertising boomed in Europe and on the other continents under an influx of the products

In the immediate post-war years, there was a distinct revolt against repressive attitudes. Jane Russell's seductive movie ad reflects the more liberal sexual morality, while a political poster in Italy depicts an angry Stalin.

which were the flower of wartime technology. As Europe rebuilt itself and the United States recovered economically at a record pace, the economic surge sent an unparalled amount of money into the developing media in order to sell the new products that the new technology could make.

The prosperity that followed the Second World War triggered a wave of spontaneity and creativity in advertising art. The concept of spending money to build an image for a product, not merely to advertise it, had not been undertaken since the late 1800s, when the trademark first became popularized. But now manufacturers pushed the image of their products, and the shape of a Coke bottle, for example, was enough to identify and sell it.

The end of World War II left advertisers standing at the threshold of the modern era. After the war the public was ready to accept the influx of new products on the market. The technological legacy of the war generated new goods for years to come, and with the entrance into the Space Age, the pace of communications would speed up and advertising would disseminate images in new ways.

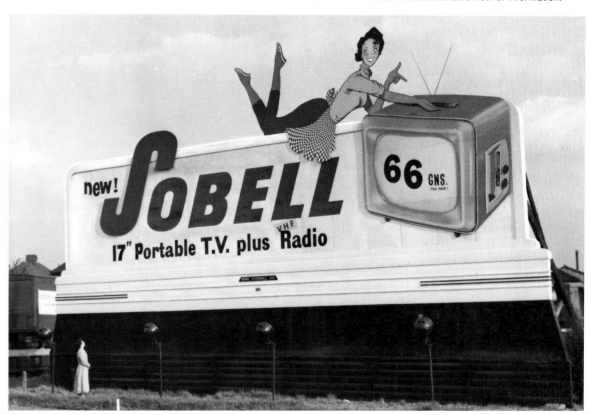

2

The 50s: The Golden Age of Paint

In the billboard trade the 1950s, known as the "Golden Age of Paint," ushered in the hand-painted billboard as a primary force in advertising. The painted billboard—bigger, sleeker, glossier than its printed poster counterpart—began appearing with increasing frequency worldwide. Since billboards permitted larger images than those found on posters, and even included plywood extensions cantilevered off the top and sides, these boards generated a different kind of visual excitement. Now an airplane advertising a trip to some exotic spot could actually spread its wings into the blue sky around the billboard.

Many advertisers earned the title of "Classic Paint" in the United States billboard industry with their outstanding national campaigns. Some classic 1950 product campaigns were produced by Buick, State Farm, Van de Camp pork and beans, Morton Salt and Wilson meats, all of which were known to just about every American who drove a car.

In fact, the fifties was the first decade in which advertising techniques could be compared to those of more contemporary media, or judged successful by today's competitive standards.

The design of goods and products, from furniture to grocery packaging, became simpler, starker and more sophisticated. Advertising followed suit with angled, geometric forms, similar to those of the Art Deco period, but with an asymmetrical and streamlined effect. Now ad imagery could utilize partial drawings and photomontage. The break-up of the picture plane grew commonplace, with only simple lines, shapes and structures. These attempts to look "modern" reflected the move of post-industrial society into the Atomic Age, symbolized by the flight of Sputnik.

Among the beneficiaries of the technology created in World War II was the commercial airlines industry. With planes like the DC-6 which were originally designed to carry troops, people could now fly across the continental U.S. in approximately ten hours. Aside from the speed and convenience of air travel, advertisers played up the comforts and amenities of inflight services. As airplanes and eventually jets became more sophisticated, the industry more competitive, billboards for airlines featured the extras: more leg room, meals and movies—and finally exotic locations which could be reached through their services.

The 1950s was at best a cultural paradox, full of conflicting tendencies. On the one hand, after the ordeal of the Second World War, popular sentiment, greatly influenced by the media, favored a return to the bourgeois comforts of home and family. On the other hand, there were those in the fine arts moving in another direction, rejecting traditional values and seeking new modes of perception, new ways of feeling.

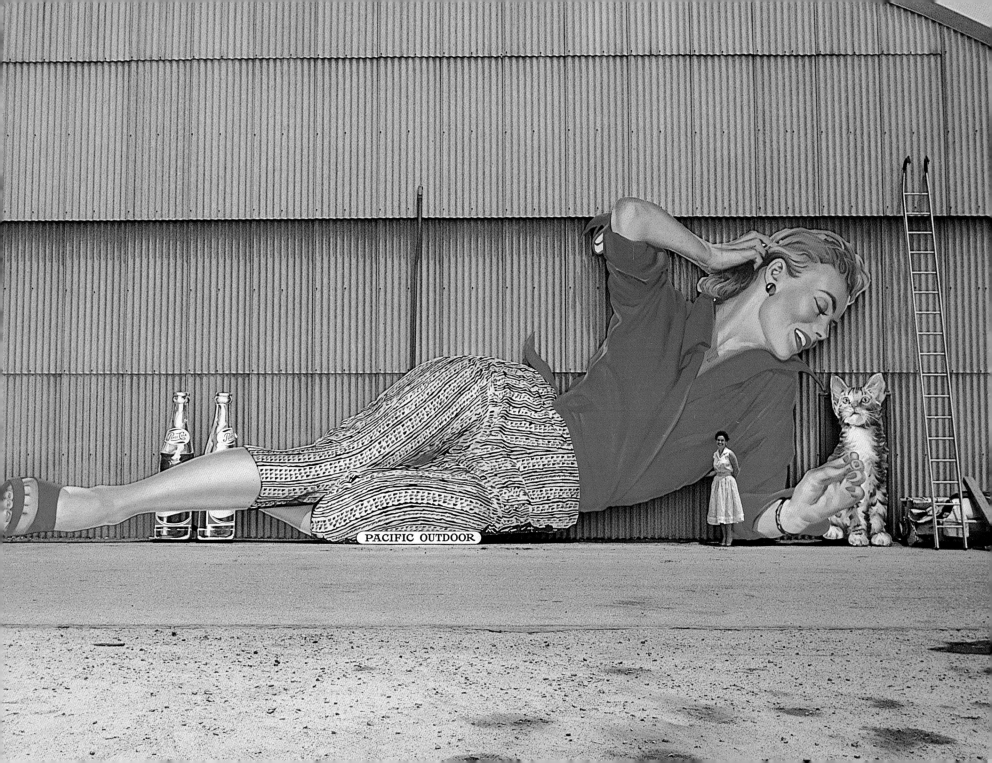

PACIFIC OUTDOOR

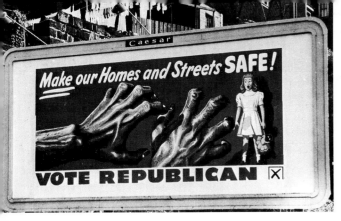

A political billboard in Pittsburg attempts to sway voters by arousing their fears (left). A tuna ad featuring a mermaid is representative of the trend of using cartoon and imaginary characters (below). This element of fantasy recalls the idealized and fanciful quality of pre-war advertising.

Popular notions of attractiveness and social acceptability are used to promote Coca Cola in England (opposite page, left). The cut-out extension allowed billboard images to extend beyond their moulded frames, better creating an illusion of depth. A burgeoning beer market effectively used this new technique (opposite page, right).

The Beat Movement and the Black Humorists were generating international changes in the world of literature. Simultaneously, the newest school in the fine arts, Abstract Expressionism, was breaking with the conventions of a literal interpretation of reality.

Subjectivity entered the field of advertising art when this new school, pioneered by Jackson Pollack, came into vogue. In Pollack's work, in place of a landscape or a portrait, paint itself became the subject. Realism disappeared as "action painters" splashed and threw color across their canvasses. Abstract Expressionism gave billboard art its first real stylistic freedom.

The public was receptive to these new developments in art and advertising. With their vision made too sharp, too clear with suffering, people turned from the awful realism of war. They had lost the desire to experience life with such profound and terrible clarity.

As a result, the most successful ads portrayed events and products with less than complete realism. Billboards that had once featured soldiers reaching out imploring hands now offered more stylized, subjective treatments. And the advertisers—growing increasingly rich and daring—encouraged art directors to cast inhibitions aside and employ whatever techniques they felt would sell products.

During the 1950s the artistic pendulum

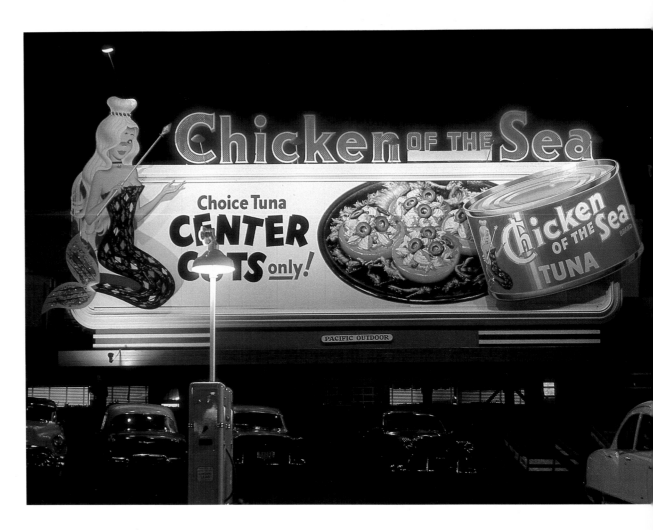

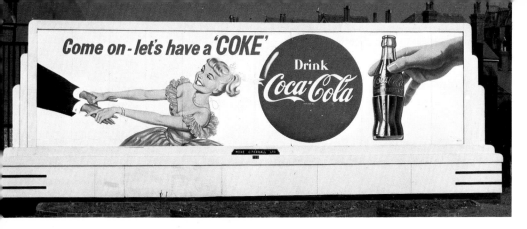

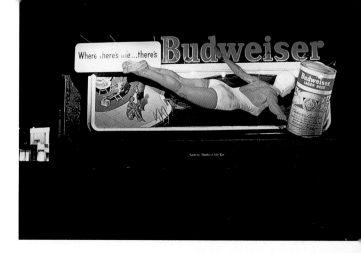

swung heavily from Paris to New York: the United States, for the first time in the world of art, was coming into its own. Still, the abstract art movement developed out of a European tradition born in the early 1900s, a tradition rich with experimentation, nonrepresentative and spontaneous. It provided the basis for much of the advertising imagery produced from the 1950s on.

In the early decades of the century, painters had been reevaluating the way subject matter was portrayed. Already, established schools like Post Impressionism and Cubism had begun this process by changing the recognizable image. Post Impressionists like Van Gogh and Cezanne used exaggerated brushstrokes and quick, unsubtle color changes to embue their work with emotion. Realism was not their primary concern.

Abstraction took another step with Cubism. Picasso dissolved his subjects into angular planes and the images became dislocated and primitive. Mondrian's work at his most extreme was limited to horizontal and vertical lines and to the use of primary colors and black and white.

It was Marcel Duchamp who took abstraction to its furthest limits in a movement he called "Dada." Picked at random, the term meant "hobbyhorse" in French, and served to underscore his nihilistic vision that art in the face of global war was meaningless. Duchamp was one of the first artists to take ready-made commercial objects such as bottle racks and shovels, sign them, and call them works of art.

Advertising and billboard imagery after 1945 took many of its shapes and designs from the art movements of Dada and Surrealism which preceded the war. Commercial and fine art were exchanging many ideas, and often it was the commercial use of an art trend that made it completely acceptable to the public. Surrealism, classically exemplified by Dali's famous dripping watches, introduced a dreamlike and disconnected quality into art. In the 1960s, the commercial artifact once again became art, with Andy Warhol's soup cans and Brillo boxes.

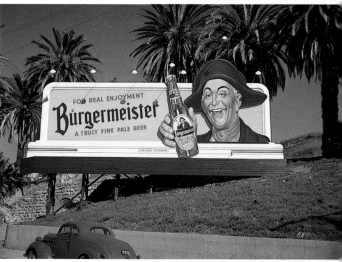

Naturally enough, this rich legacy of abstraction had a tremendous influence on billboard advertising, changing relationships of scale and proportion, turning inanimate objects into characters with distinct personalities. Suddenly, billboards depicted human figures larger than houses; a girl and a milk carton stood the same height; animals acquired human characteristics; objects, broken free of their moorings, floated in space.

The concept of a painting or billboard as a window looking out onto another world or image was an old and traditional idea. But, as the format of the billboard grew larger, art directors began to dismiss the idea of the billboard as a picture frame or window.

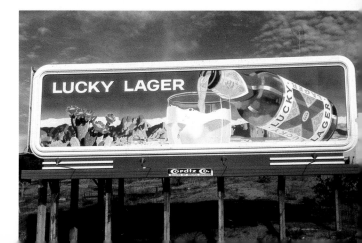

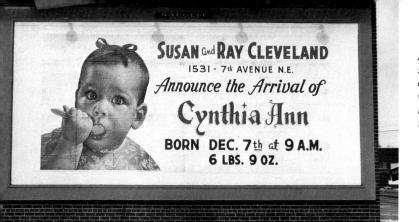

A billboard rented for personal use in Minnesota displays a birth announcement during an era in which the importance of the family unit was stressed (left). In the 1950s advertisers realized that sexual innuendo could be used to sell anything, even candy bars (below).

The general jubilation of the post-war period died down soon enough amid the growing cultural constraints and repressiveness of the 1950s. In the United States this was a period characterized by governmental investigations of the arts—a mood unconducive to creative or intellectual freedom.

Family life was equally restrictive. During the war, women had advanced into positions previously held by men, acquiring in the process a new status and independence. But after the war, women returned to their homes and took up the tasks of child-rearing and housekeeping, and lost some of their recently acquired gains. Standards of masculine and feminine dress took on greater importance than they had for decades. Men dressed in dark suits, white shirts and narrow ties, and cropped their hair short. Women wore frills and bouffant skirts, bright lipstick and fluffy hairstyles. The contrast between the male and female costumes was particularly marked and showed to good advantage on advertising logos and billboards.

The ideal of the family was stressed as a universal good. Advertisers appealed to this sentiment with billboards picturing Mom, Dad, and the kids out for a drive in their shiny, luxurious new sedan. There was a profusion of ads featuring foods—tables groaned with meats and vegetables, breads and salads. Especially prevalent were the billboard ads for canned goods. The term "middle class" seemed to apply to just about everyone, and advertisers showed families living very well indeed. Faces were plump, pink-cheeked and smiling.

Youthful consumers, increasingly prosperous, spent more of their money on goods and products than in the past. Bobby-soxed, saddle-shoed teenagers abounded at drive-in movies and restaurants, and for the first time teens were a carefully cultivated, viable, independent market with strong and particular tastes. A large rift began forming—one that would widen abruptly in the sixties: between the traditional mores still favored by the majority of middle aged individuals, and the more liberal values of the youth market: the "generation gap."

Advertisers, anxious to capture the attention of these newly monied consumers, sold with sexual innuendo. Although sex in advertising was still considered risqué, sexual allusion now established itself as one of the ultimate marketing tools. More billboards used scantily clad models, as well as catchy gimmicks, clever come-ons, and unlikely situations between men and women.

One particularly noteworthy example is of a billboard ad showing an amply endowed nymphet. Clad in a low-cut dress and parted evening wrap,

52

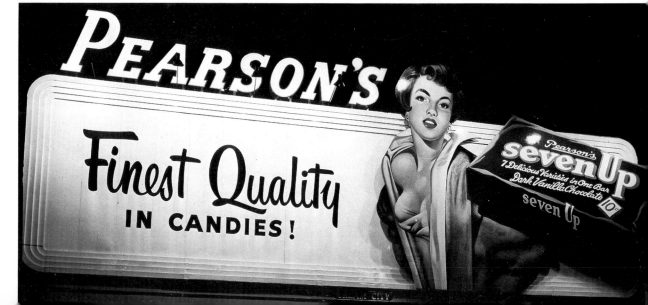

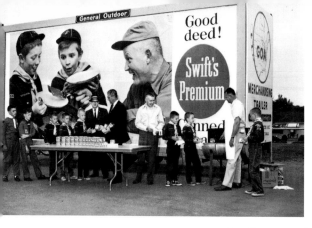

Cub Scouts are honored in a Swift's Premium billboard campaign, emphasizing good citizenship (left). An illuminated airplane display calls attention to the growing commercial airline industry. Lower fares, improved planes, and shorter flight times made it easier for people to travel by air (below).

she leans forward enticingly, her ripe lips parted. She is posed alongside of an out-sized candy bar, a Pearson's Seven Up. "Finest Quality in Candies!" the sign proclaims. There is no rational connection between the girl and the candy bar, except for the unconscious equation about the desirability of each.

After World War II billboard advertisers technically outdid themselves. They brought a multitude of innovations into the medium from all directions. Servicemen had supported a booming business for beermakers in the United States, and brewers built spectacular signs with extensions and lights in major cities from San Francisco to St. Louis. Budweiser created one billboard design, for example, of a beer bottle over ice; the bottle lit up, and the light made the ice look like glittering diamonds. Or the signs would feature bottles pouring out their contents in a splashing, gushing fountain of multicolored neon.

The neon and electric signs of Paris, London and New York surpassed themselves with spectacular advertising. The night sky crackled and simmered with block after city block of displays as brilliant as an exhibition of fireworks.

Some of the biggest problems billboard companies had experienced prior to the 1950s were the technical obstacles dictating the height at which their billboards could be installed. The technology of billboard installation had not kept

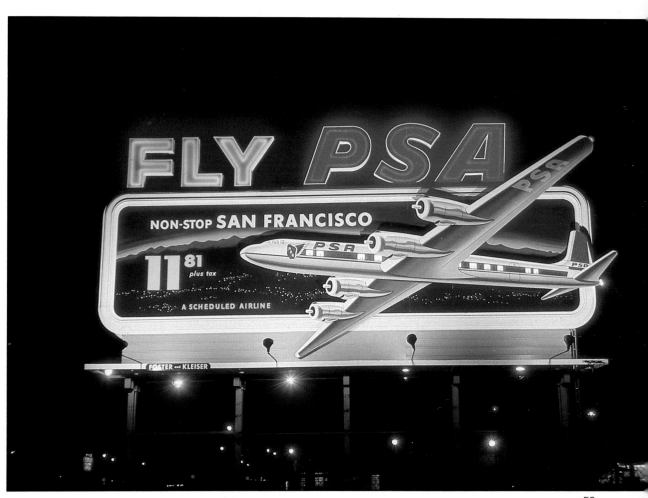

The introduction of the boom truck allowed easy installation of elevated billboards and the rotation of messages to various locations (right). The overall design and concept of billboard art kept pace with advancing billboard technology. In these intricate and carefully arranged compositions, graphic designers reinforced bold imagery with innovative techniques, including the repetition of design elements and the use of reflective surfaces (below).

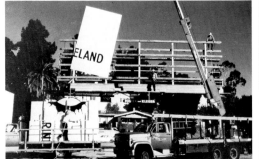
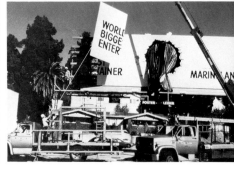

pace with innovations in building construction, and boards still remained close to the ground and less visible. But the use of the boom truck changed all that. With the aid of a boom truck, equipped with a large crane, the fourteen-foot or even twenty-foot, sections could be "racked up" onto the truck, and "boomed up" with the crane to the stories above ground.

Rooftop installations became more feasible as a result, and skyline freeway signs now took on a prime importance. The ability to install billboards at new and greater heights increased sight locations by 80 to 90 percent. Today it is no longer out of the ordinary to see giant ads on buildings of all sizes.

Sign rotation was a natural outcome of the use of boom trucks: an advertiser could now move his message all over town in a matter of months by using the same billboards and simply switching them around. The boom trucks could easily rack and unrack boards, moving them every thirty or sixty days to new locations that represented different markets, or different cross sections of people, with four months usually the maximum duration in each place. Each client would then get a repaint of the original billboard as part of the standard contract, since wind, rain and sun took their toll, with up to three repaints a year. While the billboard was undergoing its repaint, the message could be updated or changed.

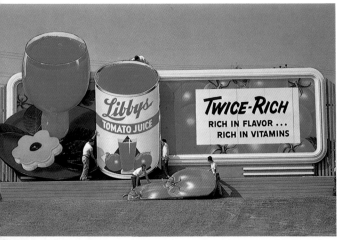

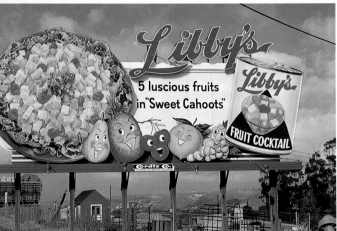

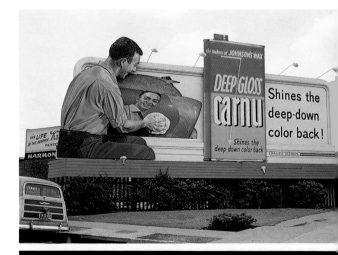

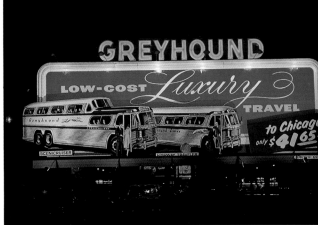

The advertisers of the fifties preferred photography to illustration, but the photographs were often hand colored, which softened the effect of the landscapes or the products being shown. Postcards which reflect the precious, naive quality of 1950s illustrative art are still being sold today. Cartoon versions of animals and children appeared, with a smooth, airbrushed or hand-painted quality. At the same time the cartoon images were popular, they were juxtaposed with the increasing sexual sophistication that had entered the market at the beginning of the decade.

The new sensibility in billboard design was due, in part, to an evolution that had been taking place in the art world for over fifty years, and, in part, to the advent of television and the faster pace of freeway travel. The format and size of the 1950s billboard had to change to accommodate the larger images necessitated by increasing freeway speeds in all major urban centers. In the United States, fourteen-foot-high plywood sections were clipped onto the billboard frame and actually covered it up. The advertiser got more square footage and images grew to an even more impressive and surrealistic size when compared to natural objects in the environment.

It was also during the 1950s that billboard companies began using cut-out extensions to accentuate their painted billboards. These

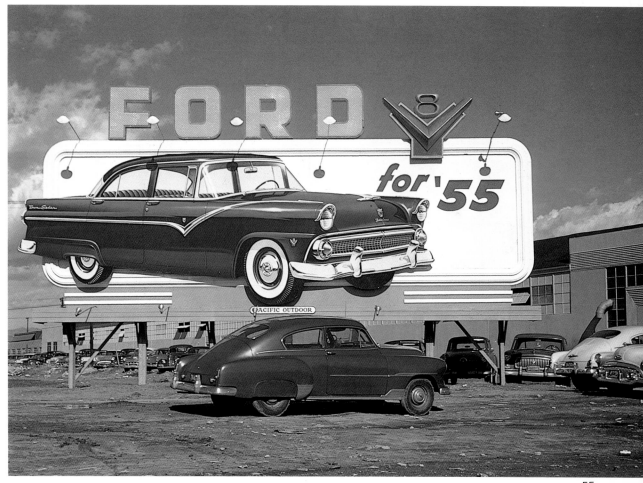

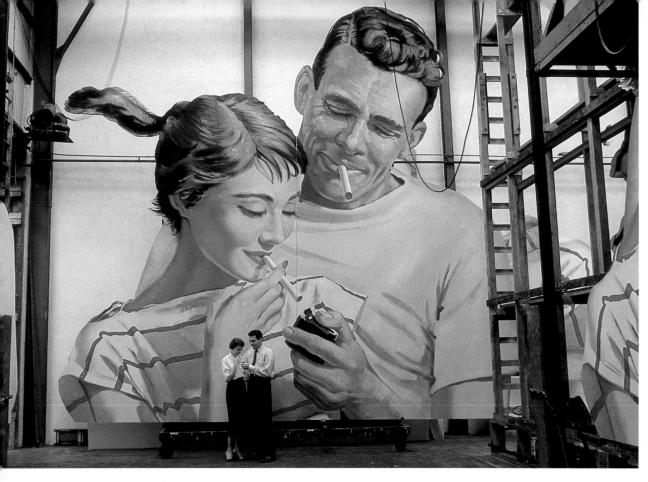

The new "gigantisme" in billboard art set the trend for the portrayal of products in larger and larger dimensions. Previously unnoticed details now make the image memorable and easier to see while driving at faster highway speeds.

Picturing items in this huge manner made the object easier to remember: people became familiar with small details that might otherwise go unnoticed. The exact shape of a Coke bottle sets it apart from any other, as does the design of the lettering on the bottle. In the 1950s, manufacturers realized that the tempo of modern life did not afford the viewer much time for reading. Accordingly, they were required to make product design and billboard format strong enough to sell the item during a few seconds of distance viewing from the window of a car.

Pedestrians and drivers learned to see these larger images, in a new light. A shining new car, fourteen feet high and forty-eight feet long leaves a lasting impression. A hamburger painted to look as big as a house takes the hamburger out of normal context, pickles, relish and all. Its size lends it a dimension of hyper-reality, in much the same way as television exposure affects the products it sells: they become larger, more real, than life.

It was television finally—the newest medium of a modern age—that rung changes on the texture of modern life as significant as those brought about by the popularity of the automobile. It had a stronger impact on the way people live than the invention of the radio, and introduced an immediacy unlike movies. Television created a more visually-oriented culture.

extensions, however, were quite different from those we know of today. Now extensions may consist of the neck of a Coke bottle extending flush off the board into the sky, or the wings of a plane as it takes off for Tahiti coming off the sides of the board.

But in the '50s, many billboards in the United States featured mouldings that ran around the rim of the board, giving it a clean, modern appearance. This moulding, however, made it impossible to run an extension directly off the edge of the board. Instead, a cut-out extension was used, in which the entire Coke bottle or airplane would be cut-out and pegged off the sur-

face of the billboard so as not to interfere with the moulding.

Often the major part of the billboard remained a cut-out, with only a few background people painted on the actual board. These cut-out extensions were expensive, but at the time, they represented the state of the art for achieving a three-dimensional look in advertising.

This new feeling expressed in outdoor advertising might be called *gigantisme*. Soon people became accustomed to seeing enormous bottles of liquor, packages of cigarettes, and bottles of Coca Cola floating above the buildings and roads.

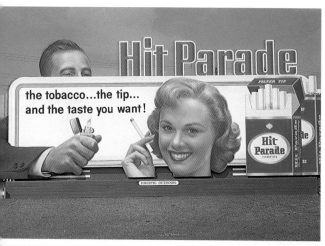

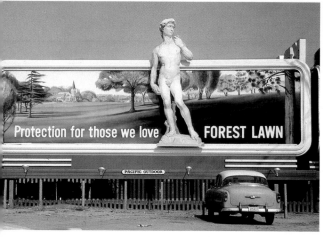

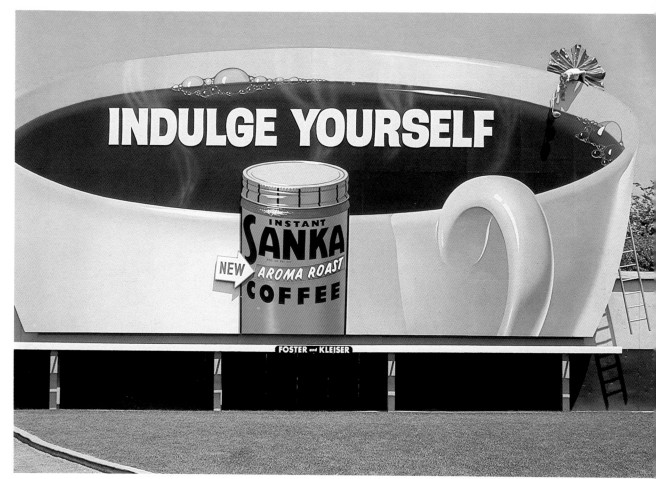

Television bombarded viewers with flickering images flashed on the screen at an unprecedented rate. Those who watched were forced to assimilate a rapid flow of impressions and ideas. They learned to meet the new medium halfway, becoming far more receptive to concepts introduced visually. Advertisers had to compete with production of new products at a rate undreamt of a quarter century before.

Manufacturers soon moved from a more neutral approach, directed at the intellect, to a more sophisticated approach that reached viewers at a visual level. Long, prosy captions and wordy exhortations were left behind in the wake of a semiclothed model entreating the consumer to buy whatever she held in her hand.

Billboard advertisers, not to be outdone, changed their tactics to accommodate buyers more interested in pictures than in text, more responsive to appeals aimed at the emotions and desires than at rationality. Billboards, like a giant television screen, were the perfect medium for the quick paced, newly visual consumers of the 1950s.

3
The Youth-Oriented 60s

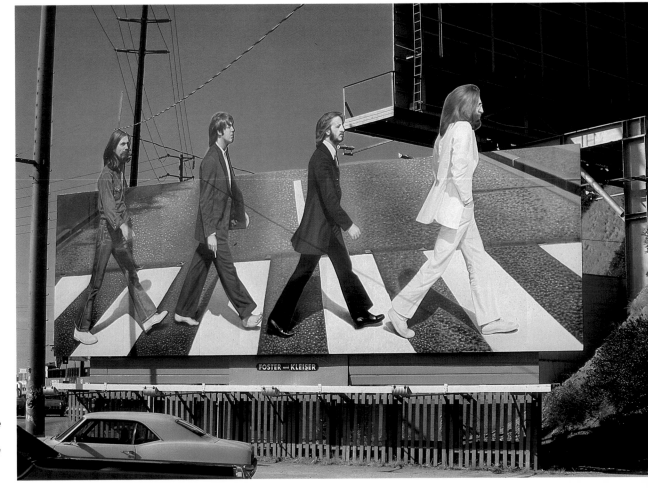

The shift toward a youth-oriented culture in the 1960s was led by the Beatles, shown here crossing Abbey Road.

The almost goddess-
like popularity of movie
stars like Marilyn
Monroe was reinforced
through larger-than-life
billboard imagery.

For the world of advertising, the social unrest of the 1960s had profound and unforeseen consequences. The youth movement raised concerns that could be addressed commercially; to meet these concerns effectively, no aspect of billboard art was left unchanged. Advertisers were forced to acknowledge the ruling passions of youthful buyers, and in time, this became the single most significant theme in marketing. The involvement of the under-30 generation with fashion, sexuality, entertainment, the arts and alternative ways of living colored the outdoor advertising of the period.

Marketing the spin-offs of successful products proved an ideal strategy for boosting sales, especially in the entertainment industry. The explosive popularity of certain film and recording stars, for example, sold far more than just record albums and movie tickets. T-shirts and jackets, posters, calendars, buttons and flags, even dolls, found plenty of buyers, as long as they bore the image of the latest idol.

Spin-off marketing eventually gave rise to the entertainment conglomerates of the present day. These companies produce films, novelizations, television programs, sound track albums and other subsidiary products all based on single concepts.

The same marketing strategy made the superstar phenomenon possible. Now an entertainer was promoted as if he were larger than life, appearing everywhere—in films, television, recordings and print—endorsing anything, and holding a broad-based international appeal. In major cities billboards helped create this kind of popularity for groups like the Beatles. The billboard became one of the most important vehicles for the international packaging and promotion of entertainment, and superstars in particular.

The explosive reception of British singing groups, especially the Beatles, paved the way for the mod look, including unisex hairstyles and fashions. Eventually, men could wear bright colors, shoulder length hair, and buy off-the-rack clothing, just as women had been doing for decades. The mod look influenced cosmetic advertising as well, offering a blonde, British, pink-cheeked, little girl look. Youth, beauty and sexuality were becoming identical in the popular consciousness.

New styles in the arts and advertising were indicators of these cultural trends and helped to create them. Op, Pop, and psychedelic art were powerful tools in the hands of advertisers and very successful in stimulating sales.

Op art used optical effects to fool and disorient the eye. It could lay no claims to subtlety. The colors were blatant; the lines, grids, and circles jumped and danced about, refusing to stay still. But Op art did something of primary impor-

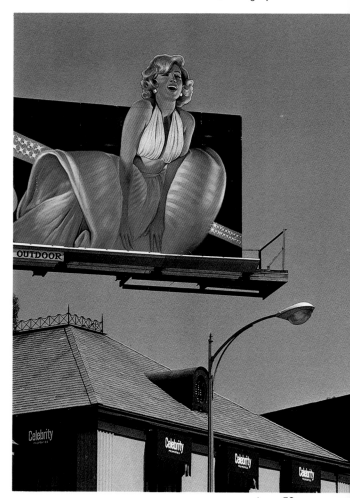

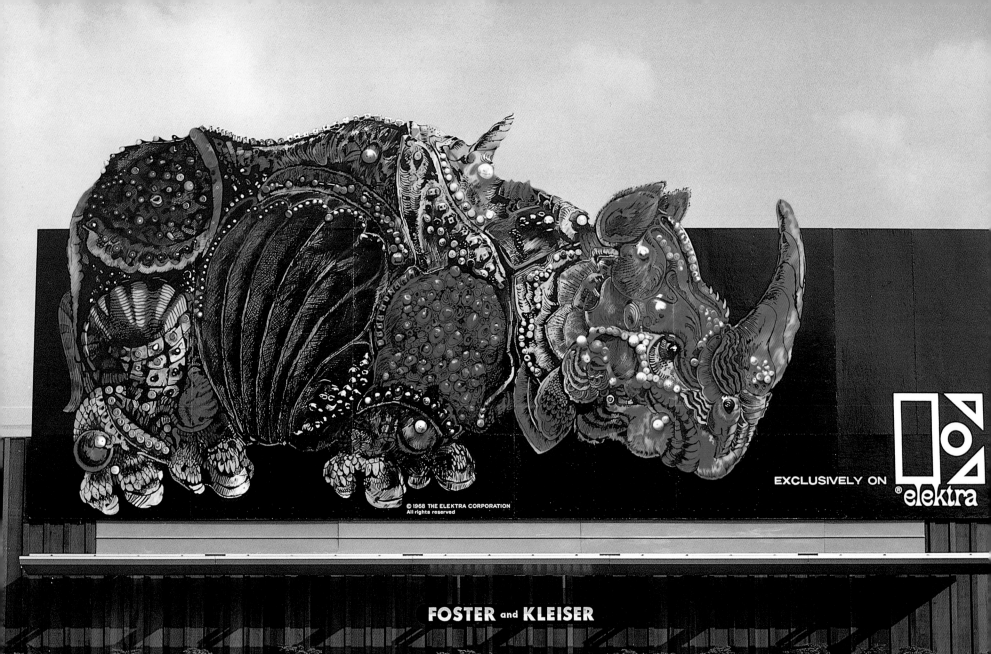

EXCLUSIVELY ON

elektra

© 1968 THE ELEKTRA CORPORATION
All rights reserved

FOSTER and KLEISER

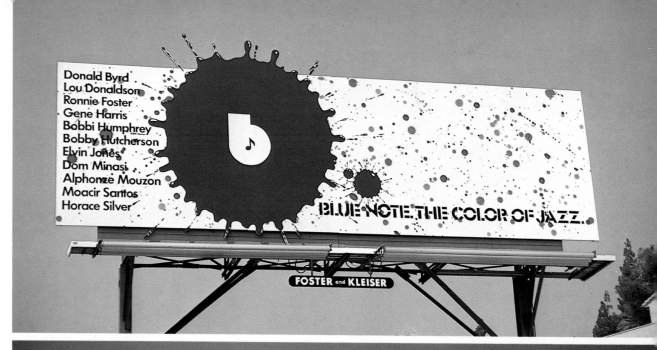

Art trends of the 1960s exploded with vibrant color and energy, using fluorescent paints and optical illusions—techniques which had been introduced by billboard art. The growing acceptance of drug use by middle-class youth led to imagery like this psychedelic rhinoceros used to promote a record label (opposite page). Op art, a trend toward disorienting optical effects, gained the viewer's attention through repetitive patterns (bottom right). Other billboards borrowed the spontaneous quality of Abstract Expressionist art (top right).

tance to advertisers and billboard art directors alike: it grabbed the viewer's attention with unrivaled force.

The new, eye-catching optical tricks could be applied most effectively to billboards. Billboards provided the largest area to work within; they called for the brightest colors, and their visibility was of paramount importance. Wavy lines pulsing with energy and optical sunbursts streaming from bottles of dish detergent and new cars enticed the onlookers to fix their attention on the products.

The use of color became a significant tool in manipulating the perceptions of the viewer. Through variations in the shade and intensity of color, pedestrians could be made to regard one ad as somber, one funny; another as reassuring, and still another as violent or shocking.

The psychological impact of these techniques on individual consciousness was of great importance to painters of the period, especially Vasarely. A leader in the field of Op art, he chose variations in color scales and grids to make the flat canvas appear to move and change shape and dimension internally.

With the arrival of the drug culture came psychedelic art. Billboards blazed with fluorescent paint, vibrant and unreal, and a combination of Op art and Surrealism. The relative proportions of people and objects inside the billboard frame

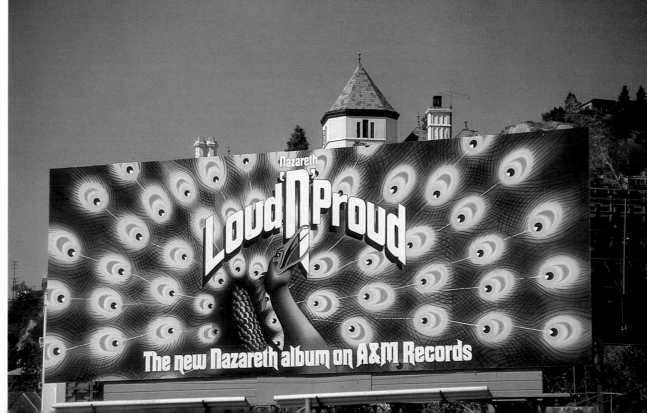

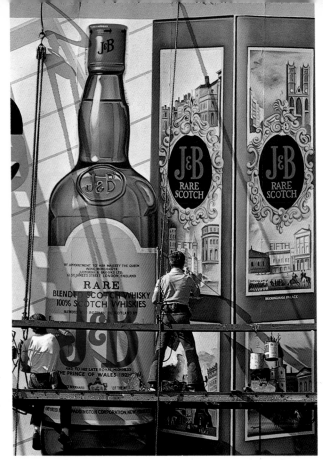

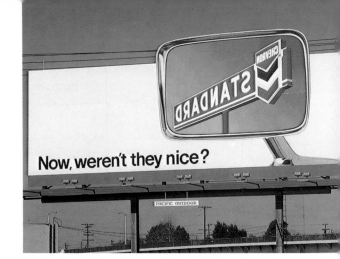

Now, weren't they nice?

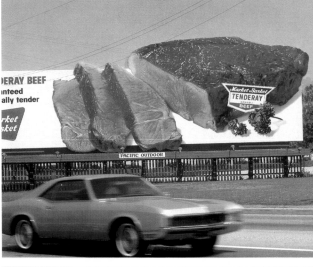

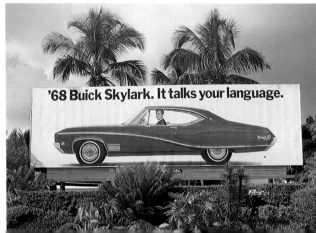

'68 Buick Skylark. It talks your language.

Perhaps the most important art movement to emerge in the 1960s was Pop Art, which incorporated commercial imagery into fine art. Billboards of this period influenced Pop artists who were reacting in an ironic and whimsical way to an increasingly materialistic and consumer-oriented society.

became fantastic. At times commercial artists departed from conventional reality and tried to evoke the imagery of drug-induced visions.

Elaborate designs that recalled the Art Nouveau period abounded. Lacy circular mantras, twining tendrils and floral patterns, baroque curlicues and delicate paislies could be seen everywhere, on billboards and television, in packaging and on posters.

Perhaps the most memorable artistic phenomenon of the 1960s to come along since the earlier action painters was the movement called Pop art. It could be seen as a natural backlash to the Abstract Expressionism of the 1950s, a return to realism in painting. But Pop signaled an unusual return, one that disturbed most people

outside the arts as much as action painting had first done. This was realism that parodied realism.

Pop art, by refusing to draw the line between commercialism and fine art, emphasized a new image of man and his environment. Pop took an uncritical look at its country of origin, here and abroad, and delivered an uncensored view, on a giant scale, of the young, hip, object-oriented society of the sixties. Small details of the common, everyday and familiar were blown up larger than life, in much the same way that billboards had displayed objects all along. Instead of the private, personal feelings of the artist, the viewer beheld impersonal media images.

Yet the movement did not idealize its subjects in the traditional painterly mode; the work always had a tongue-in-cheek quality. Warhol displayed wallpaper flowers and giant Brillo boxes; Oldenburg stitched and stuffed soft sculptures of ordinary household items like ice bags, hamburgers and giant electric switches.

Other Pop artists—Rosenquist, Wesselman and Lichtenstein—isolated their subjects, giving the viewer a chance to take a new and penetrating look, one that discovered fresh details. Many of the artists involved in the movement had been working in some form of commercial art during the earlier part of their careers. Rosenquist, an ex-billboard painter himself, created commercially realistic murals. Wesselman assembled his

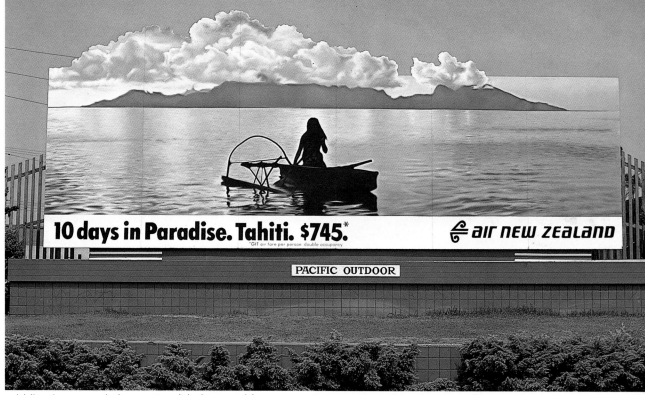

"American Nudes," which were painted flat and lifeless, in three-dimensional rooms built to house them comfortably. Lichtenstein took comics out of the newspapers and into the museums.

The Pop art period was the most important fine art movement to develop in relation to outdoor advertising. Suddenly, fine art looked like billboards, and billboards looked like fine art.

The use of the commercial image in fine art had not been attempted since the time of Duchamp; but Duchamp's vision was negative and remorseful. Warhol's depiction of popular culture through Pop art was, on the other hand, a whimsical social statement, one easier to live with than that of the Dadaists. Pop art was attractive, and to viewers who were by now extremely visual, it was already a part of their everyday reality.

The link between Pop and commercial art was so close during the sixties that it brought about a marriage of the two. Images in museums and in advertisements, painter's canvas and packaged products, were practically interchangeable. Fine art at last became accessible to average people; it imitated everyday human experience. The Pop artists asserted that ordinary objects could be aesthetically meaningful, even though they were as commonplace as a soup can.

But political and cultural values shifted through the middle sixties and many comfortable, middle-class people began to wish they could escape to a less restrictive way of life. Billboard artists played on this desire; and the cozy kitchens, the secure overstuffed interiors of the fifties, disappeared once and for all. Increasingly, artists put their models in outdoor settings.

The spectacular use of color on billboards deepened the freshness and appeal of these outdoor scenes. Blue sky and water, green grass and trees, a multitude of earth tones, golden sunshine, brilliant sunsets, provided an ideal showcase for a variety of products, from beer to cigarettes to sporting goods. For the viewer, it was easy to associate the items with the free and wholesome atmosphere portrayed.

Rugged mountains, white water and golden seascapes added an exuberant, liberating quality to billboard messages. For consumers walking the crowded, dirty streets and commuters caught in traffic jams, the images of nature provided a visual escape.

Concern for the environment, pretty well forgotten amid the 1950s expansion of industry, was becoming an increasingly popular issue during the 1960s. For the most part, billboards and signage in general went unquestioned, but the age of urban remodeling and redevelopment was at hand. Massive clean-up programs for the inner cities in both the United States and Europe were beginning to lead to new programs of outdoor advertising.

The technological expansion of the previous decades brought with it a proliferation of unregulated signage, accompanied by a negative impact on the environment. It is indisputable that billboards and signs can become environmental eye-

63

A kiosk in Paris, normally used for commercial messages, displays the work of Op artist Victor Vasarely (above). A poster stand in Moscow features announcements of cultural events (below).

sores. In the absence of sufficient controls placed on independent, small business signs, or on the outdoor industry itself, there is a lack of control over what appears on the streets. Because of the lack of planning inherent in the incredible growth of urban areas after World War II, redevelopment was desperately needed for modern cities. The center of cities had been destroyed or had deteriorated and been left to decay amid rapid suburban growth and the continuous exodus from older neighborhoods.

City planners began to lay down new rules for outdoor signage, even though some were reluctant to address the issue at all. In England, massive changes were necessary in a system over fifty years old. The traditional idea of the English hoarding, in which construction sites, industrial or refuse areas were covered by one- or two-story plywood walls and then plastered with ads, needed to be improved upon.

Determined to remain in the picture, but realizing that their industry needed help, British billboard advertisers turned to outside professional guidance. Architects who had worked on the redevelopment of Birmingham, England, were hired to analyze the billboard, in both commercial and aesthetic terms. This study resulted in the design for a basic panel, similar to those used in the United States but smaller. The panel was made in proportion to human scale, and can be used in a series of modules around an area or building. It is sufficiently large to provide visual impact, but at 60 by 40 inches, using four poster sheets, it commands the viewer's attention without ruining his view. Revamping the English billboard in look and size, and redesigning the outdoor poster brought the industry in England into the twentieth century.

Billboard designs in Great Britain were better integrated with the environment at the drawing-board stage, and since there were fewer sites available, the street positions were picked much more carefully. In 1968 the British initiated a new lighting system where the posters were mounted between two sheets of acrylic with internal lighting behind them. The billboard now had a clean look to it. Not only did this eliminate on-site pasting of the poster paper, it left the board unaffected by the elements.

Environmental control has been of value to the outdoor industry. Without it they could have easily been banned from many major areas. The broader aspects of city planning have led to the total orchestration of varied elements including trees, planted areas, seats, lighting columns, and poster structures so that a planned effort will make it all work harmoniously. If an urban area appoints a design council to approve whatever goes into the environment, the aesthetic quality of life in the area improves.

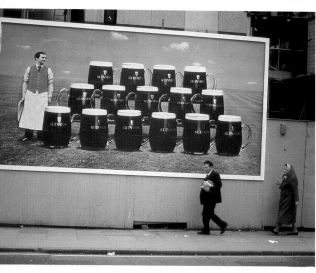

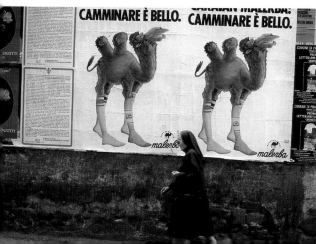

European outdoor advertising is geared for the most part toward pedestrian traffic. Though smaller than American billboards, these ads are equally effective due to their street-level placement.

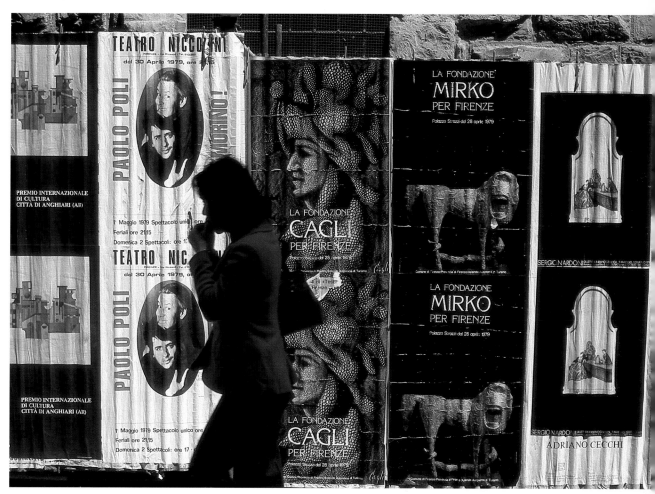

This Black Velvet campaign (opposite page) combines two sure-fire suggestions to promote its product: elegance and sex.

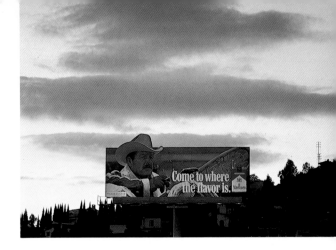

The Marlboro cowboy, evoking images of the Wild West, independence and solitude, has been one of the most successful long-running, worldwide advertising campaigns.

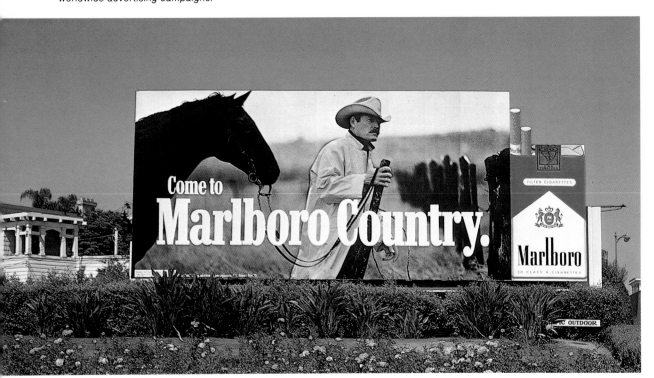

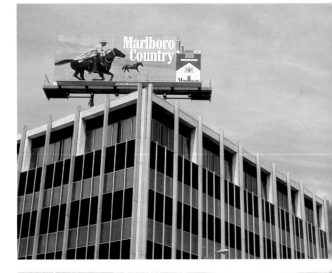

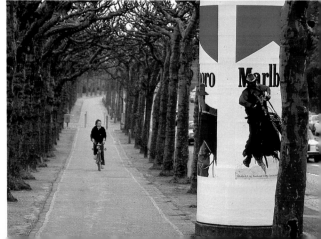

The desire, evidenced in billboard advertising, to return to a more natural ambience also expressed itself as a fascination with the Old West. The American romance with cowboys only grew stronger and more enduring in the 1960s. The figure of the cowboy sold products as effectively as that of any beautiful woman. The Marlboro Man has had a long-standing international appeal as well; this ad campaign met with a high degree of success in Europe and in the Far East. In an increasingly complex, technologically sophisticated society, the cowboy image calls up the longing for simplicity and independence that has been lost.

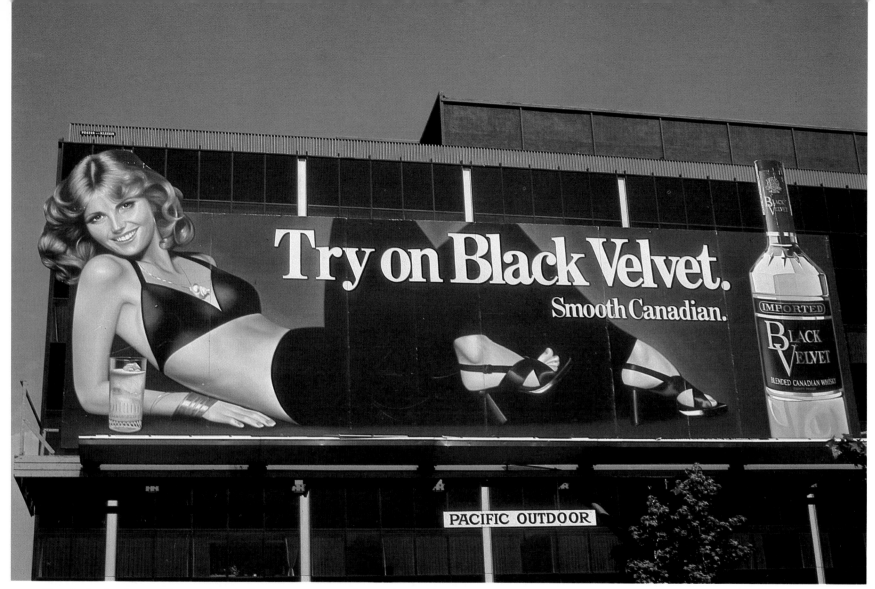

The desire to shun artifice and seek direct, authentic experience brought about a greater acceptance of sexual expression. Sex had always sold products, and outdoor advertisers had used it before, but during the 1960s billboard art became more suggestive and erotic.

The form this took was primarily the appearance of more bare skin than viewers might have found acceptable in the 1950s. Beautiful young men and women were photographed wearing scantily cut swim and sportswear. And the body itself came to be treated as an object d'art, through the use of body painting and colorful, bizarre costumes that emphasized the figure, a feature of much psychedelic art.

Beautiful women in evening dresses had long been effective as images in advertising, but now they began to proliferate on billboards. A woman's face and a woman's figure sold equally well to both sexes. The men coveted, the women competed, but everyone bought the products.

67

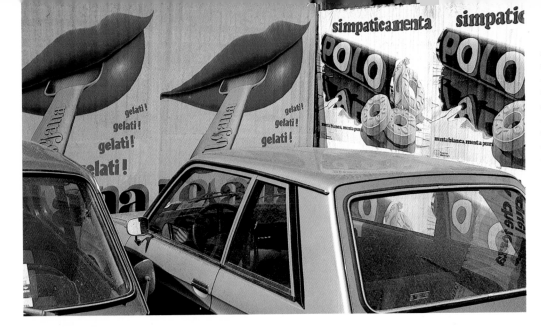

Although advertising had previously used sexual innuendos to attract attention, it was the sexual revolution of the 1960s that opened the door for even more blatant imagery in outdoor advertising. The Rolling Stones' "Black and Blue" promotional billboard (below) so offended a women's group with its violent imagery, that its members graffitied the board and protested until it was removed.

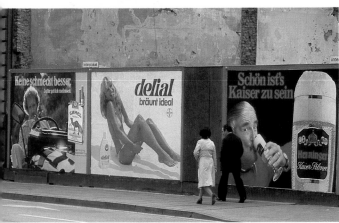

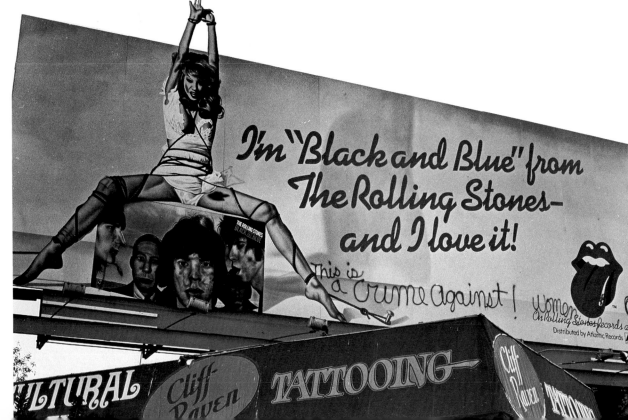

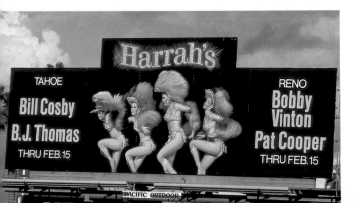

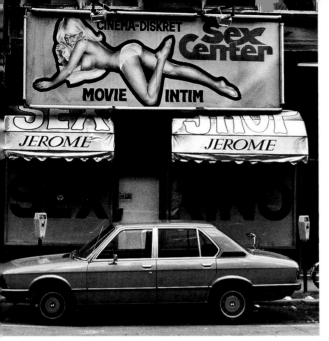

Smiling women in bikinis or low-cut evening gowns stretched languorously on the hoods of shiny cars, seeming to imply that they were part of the package.

The new sexual openness took another form. If the 1950s was the decade of the family, the 1960s became the era of the single lifestyle. Divorce rates were climbing; people started waiting longer before they married; couples chose to live together and to avoid matrimonial ties.

In response to this trend, billboard artists dispensed with the familiar, cozy images of home and family. They started emphasizing models in their late teens and early twenties, and the images of middle-aged persons and children grew scarcer. Models were often pictured alone, as with the strong, handsome, ultra-masculine young men in the Winston cigarette ads. Cowboys in faded jeans, fishermen in shiny raingear, lumberjacks in plaid workshirts all stared levelly at the camera, cool and alone in their hard physical jobs. No home and family for these men—no women, even.

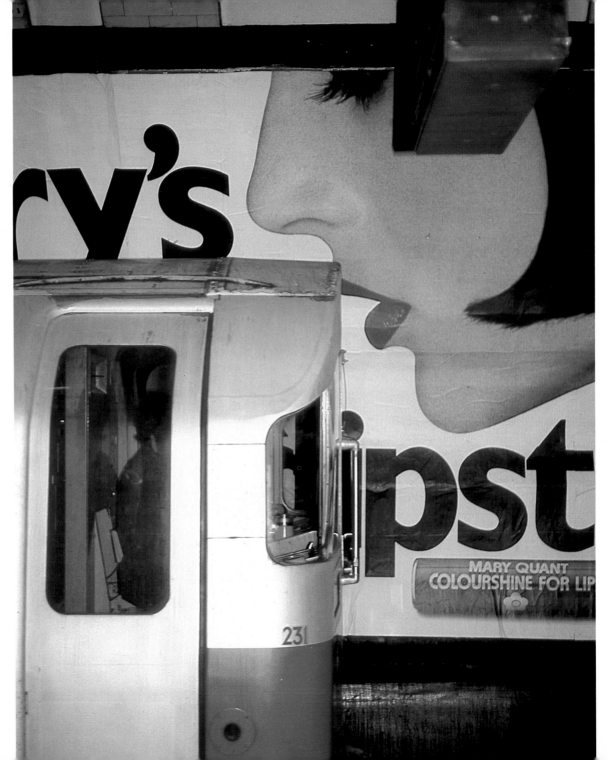

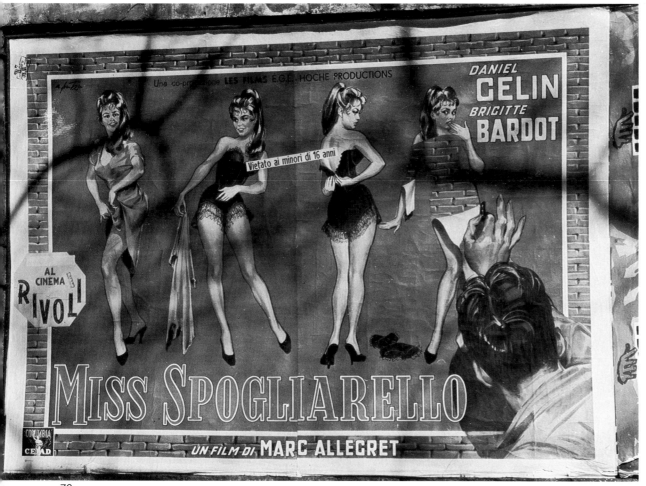

A clever Italian film poster appears to be peeling off the wall right along with Brigitte Bardot (below). English (right) and American (opposite page) billboards use less subtle ways of depicting nudity.

'Poundstretcher low fares' to the South of France from £59 return.

British airways
We'll take more care of you.

When billboards did show couples, they were without wedding rings and children and were obviously meant to be taken as young lovers. Laughing and carefree, they were often in playful poses—climbing trees, picnicking on the grass, splashing in the surf. Without exception, they were tanned, and slim and superbly attractive.

Validating the single's lifestyle made good business sense. A family with children may still buy only one refrigerator, for example. On the other hand, if a significant portion of the buying public chooses to remain single, manufacturers can sell many more of the same item. Thus the rising divorce rate proved a boon for business.

The mobility afforded by the automobile has been tremendously significant for buying patterns. The most mobile buyers, those with the greatest exposure to billboard advertising, are affluent, well educated and in the eighteen to forty-nine age bracket. A successful ad campaign will target this population.

Such an approach cannot fail to succeed as long as the majority of persons between their teens and their forties continue to see themselves in a particular light. They have no strong desire to be identified as workers; they invest their money and energies in consuming products and leisure-time activities. They buy sporting goods, alcoholic drinks, cigarettes, and sports cars, as reflected in

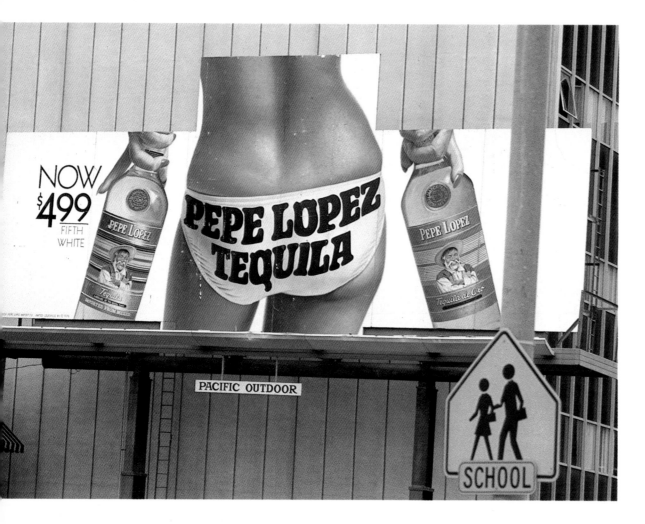

NOW
$499
FIFTH
WHITE

PEPE LOPEZ

PEPE LOPEZ
TEQUILA

PEPE LOPEZ

PACIFIC OUTDOOR

SCHOOL

international billboard campaigns.

The youth movement also excited an interest in foreign and exotic cultures among American and European buyers, and those in the Far East. With this interest has come a corresponding taste for other cultures' products. In the United States, in the 1950s, the situation was entirely different. The average consumer was more apt to "buy American" as a form of patriotism. A decade later, buyers were enticed by the notion that goods from other countries were richer, finer and altogether superior to domestic products. The same was true in other nations.

Cultural values and standards of living differ worldwide—enough so that some images will always sell better in certain countries. Commercial artists found that the automatic appeal of anything exotic included the models on billboards and not just the products they promoted. Ad campaigns featuring blonde Caucasian models did very well in Japan, for example. And the image of a beautiful black woman inevitably sold products in France. In the United States, Asians were associated in the popular mind with a mysterious allure, and their pictures worked successfully on billboards.

In addition, outdoor advertisers promoted certain products with better results in the more technologically advanced nations. In the United States, buyers would see more billboards with TV

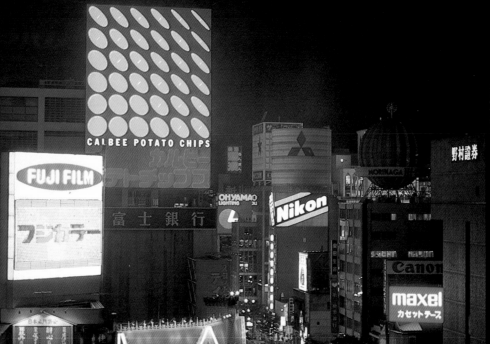

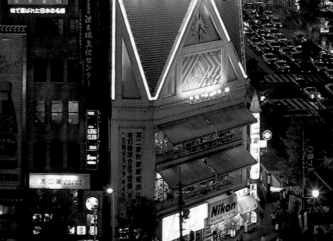

Optical patterns of neon signage proliferate on Tokyo's Ginza Strip (opposite page). A subway in Japan humorously displays a frowning Mona Lisa in a campaign against the inequities of spiraling inflation (below).

The Republic of China uses billboards to reflect the technological advances and political sentiments of its government. In Taiwan, motherhood and family were important to the product-selling campaigns during the 1960s (below).

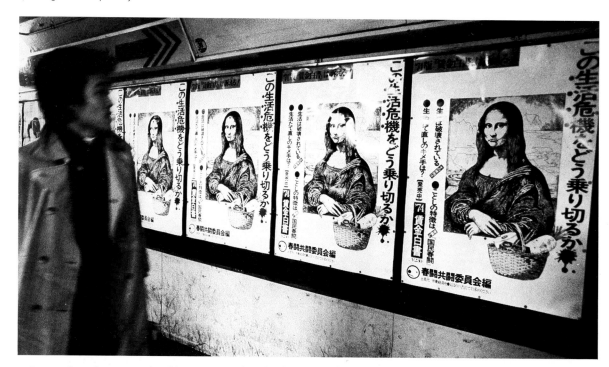

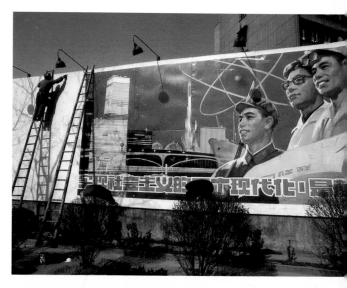

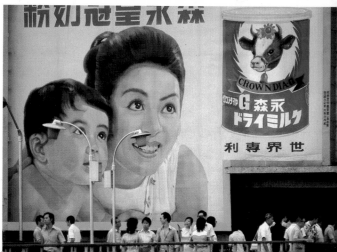

sets, washer-dryers, and refrigerators—the sleek, packaged products of affluence and applied technology. Along with automobiles, they occupied a major amount of billboard space.

In Japan, a rapidly developed country with a high regard for the benefits of Western technology, some products appeared with far greater frequency in outdoor advertising. Japan is a visually

oriented society, one that has always prized fine workmanship and detail. In the sixties, cameras, radios, hi-fis, tape recorders, calculators and business machines—as well as the inevitable automobiles—started showing on its billboards in large numbers.

The European nations are a different story. While industrialization has begun to change this

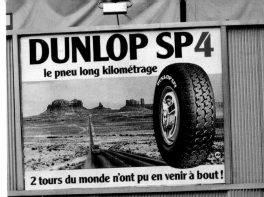

Paris

London

Florence

Stockholm

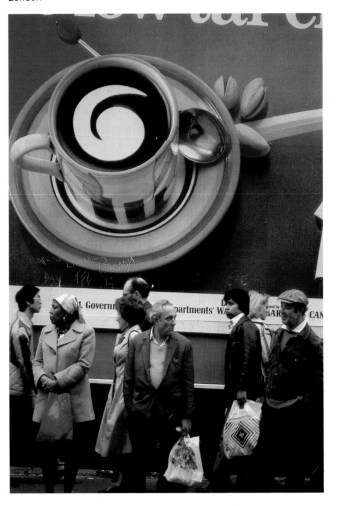

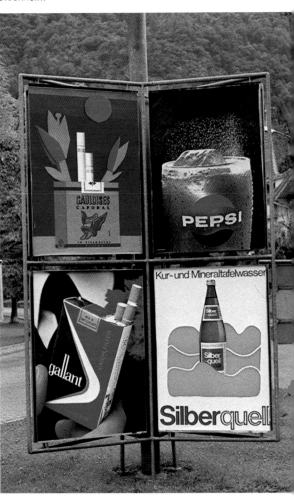

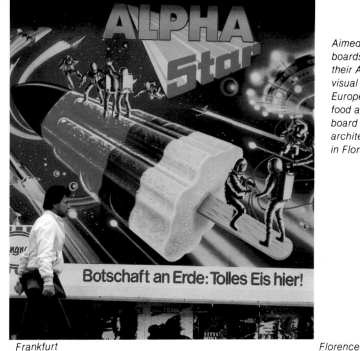

Frankfurt

Aimed at pedestrian traffic, European billboards allow for more viewing time than do their American counterparts. They use smaller visual elements and longer textual messages. European advertising tends to feature more food and clothing items than do American billboard ads, and they often incorporate existing architectural elements, such as these columns in Florence.

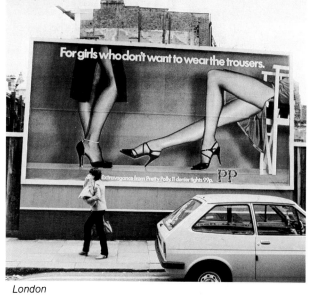

London

tradition in the more westernized nations like England and Germany, the rest of Europe has always been less involved with the more obvious byproducts of advanced technology, but more concerned with the small items that, taken together, comprise the good life; fine food and wine, for example, beautiful handmade clothes, well crafted leather goods.

Billboards in Europe tended to show national dishes, coffee, fruit, wine, cheese, and desserts. And since fine clothes are a European tradition, a great quantity of clothing ads appear with high-fashion dresses, suits, sweaters and good-quality shoes. Often the European billboards take on the flavor of magazine advertising in the United States. Stockings, which are absent from billboards in the United States, for instance, appear in European outdoor advertising.

On the other hand, certain items sold internationally and with uniform success. Everywhere in the world, you could see billboards promoting entertainment, liquor and cigarettes.

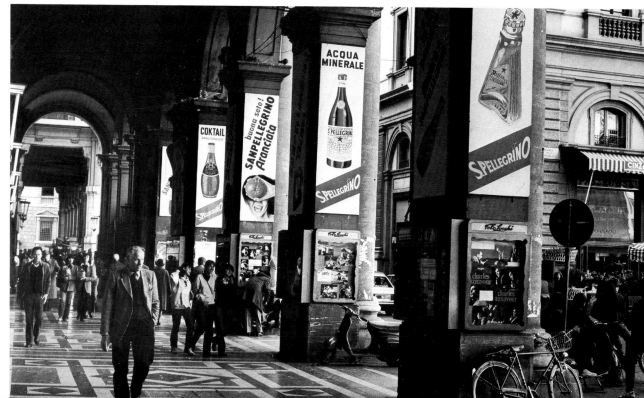

Florence

A painted board in India passionately recalls the horror of an execution (above). The proverbial dark horse (below) gets a boost from a board parading Presidential candidates, while the death of President Kennedy needs nothing more to commemorate it than its date (right).

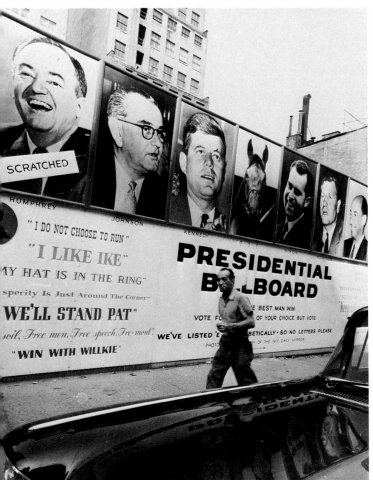

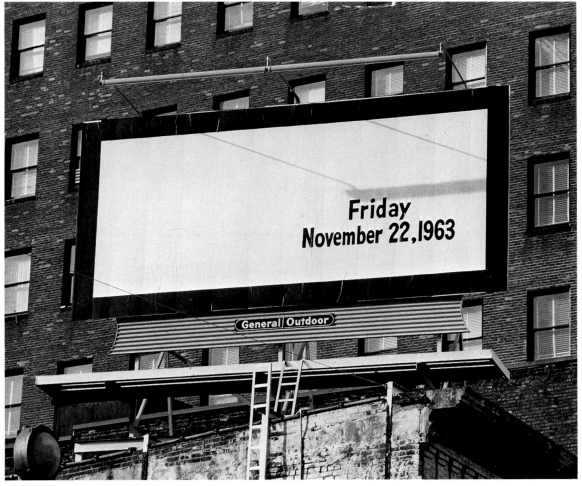

Though political patriotism and unrest were important themes in the billboard art of the 1960s, the pace of consumer sales and market competition pushed the large advertisers like McDonald's into nationwide campaigns which placed huge images of their products like giant Pop Art paintings along roadsides everywhere.

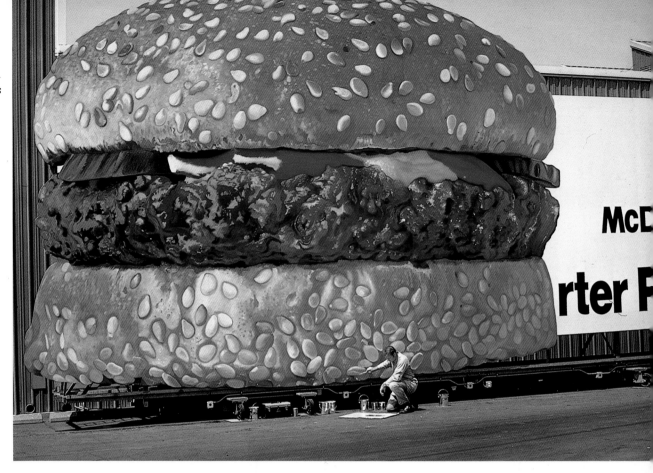

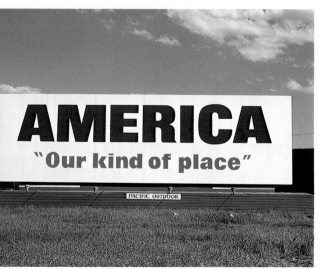

The 1960s was a landmark decade, politically, culturally, and economically. It was a wonderful, blossoming decade for advertisers. For those who suffered through the Great Depression and the Second World War, the worry about scarcity could never be entirely removed. But the decade produced an entire generation of people young enough to have escaped hunger and want. These younger consumers had the chance to develop an expectation of permanent abundance and enough capital to buy nearly anything they wanted.

Historically, the economic shift from agriculture to heavy industry made the consumer ethic possible. Technology and mass production let average people stop making most of what they needed and identify as consumers of goods produced by others. But it took the post-scarcity philosophy of the 1960s to step up production to its present level and make the modern-day market what it is.

Billboards during this decade developed their art to such a degree that the freeway landscape became an outdoor art gallery. No longer merely a form of marketing, the billboard images transcended their initial purpose to become an expansive, modern day art form.

77

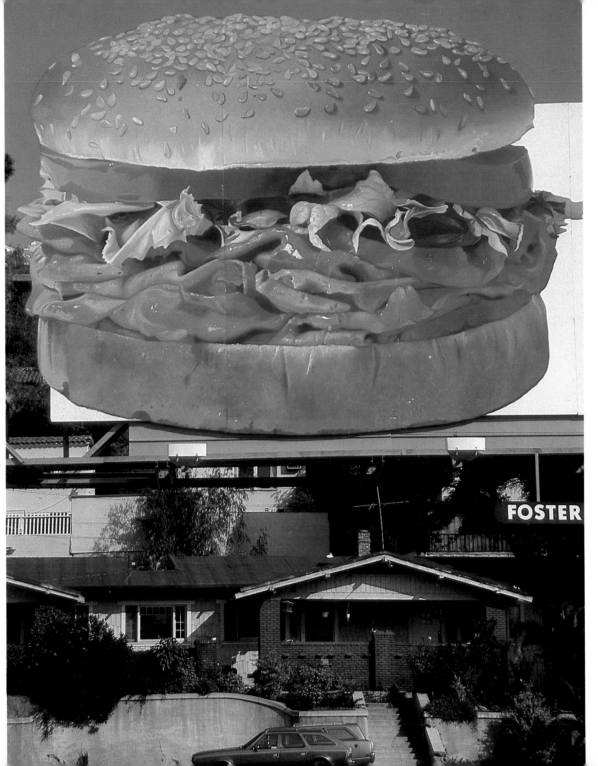

4

The Super-Realist 70s

An oversized roast beef sandwich hovers over a group of houses, dominating the landscape with its massive scale and intricate detail. This photo-realistic quality is typical of billboard art in the 1970s: billboard handpainting was so perfected that it belied its own technique.

By the end of the 1960s, in the United States many young people had become disillusioned with both the established political processes and the countercultural alternatives. Their hopes were being ground down by economic realities: jobs and money were harder to come by. Inevitably, this signified an end to idealism and a return to a more pragmatic philosophy. As a result, the seventies was a time of economic recession, a largely private era, one in which people turned their energy and attention inward, towards self-improvement and personal satisfaction.

The consumer-oriented 1970s ushered in the age of the object. Mass production and the technological, fast-paced lifestyle had effected a gradual dehumanization. Personal relationships seemed to be increasingly devalued, but the connection between the consumer and the product grew ever more important. It was no longer necessary to picture people enjoying an item in order to sell it: a Big Mac, reproduced on a billboard in super-realistic detail, could sell very well on its own. There is an instantaneous viewer response to the direct, simplistic, powerful message of this type of advertising; the product takes on an almost mythic quality when pictured alone.

One of the largest and most important items

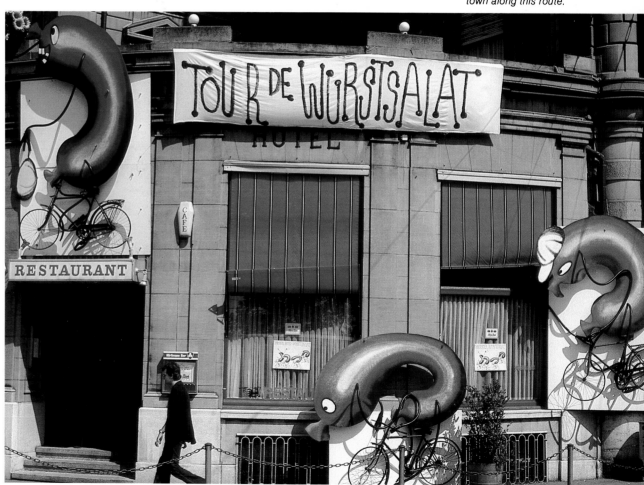

In Zürich, Switzerland, bicycling sausages announce a bicycle race that passes through the town along this route.

The superstar phenom-
enon allowed the instantly
recognizable faces of
Groucho Marx, Jack
Nicholson and Al Pacino
to appear on billboards
without captions, just as
the Volkswagen bug had
been shown.

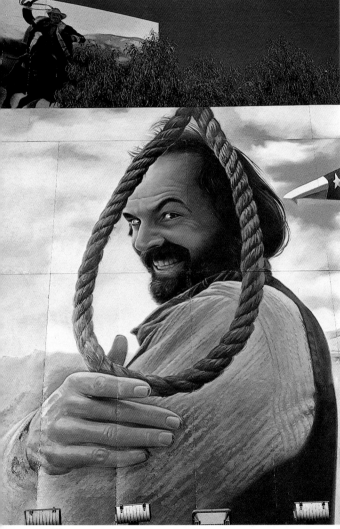

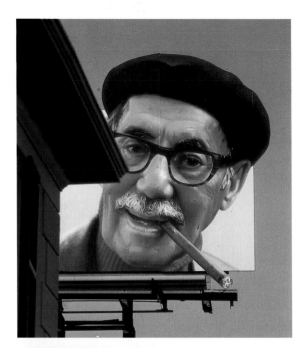

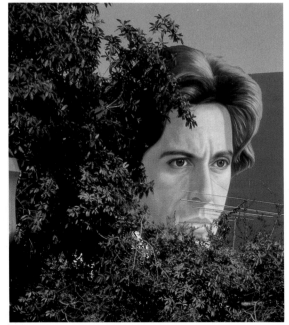

In an ad for his film
"Heaven Can Wait"
Warren Beatty appears
to be in the path of a
stampeding steer from an
overhead Marlboro board
(right).

available for consumption in the United States,
and especially the West Coast, was entertain-
ment. For millions, it filled an enormous gap. In
the absence of a religious sensibility, it answered
the need for myth and heroes. And if stars are
cult leaders, then the billboards showing them are
the icons of that religion.

A star "image," an abstract, intangible com-
modity, is packaged and sold internationally
through billboards. Billboards helped to market
the quintessential creation of the 1970s—the
superstar. There is only one way to determine if a
celebrity has achieved superstardom; his picture
can appear on a billboard, minus a caption, any-
where in the world and he will be recognized
immediately. Only a few individuals—Barbra
Streisand, Marlon Brando, John Wayne—are
among those who have achieved that kind of
status. Like the Volkswagen bug, they need no
caption.

Some of the most unique examples of bill-

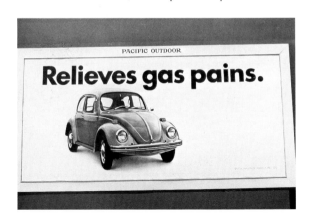

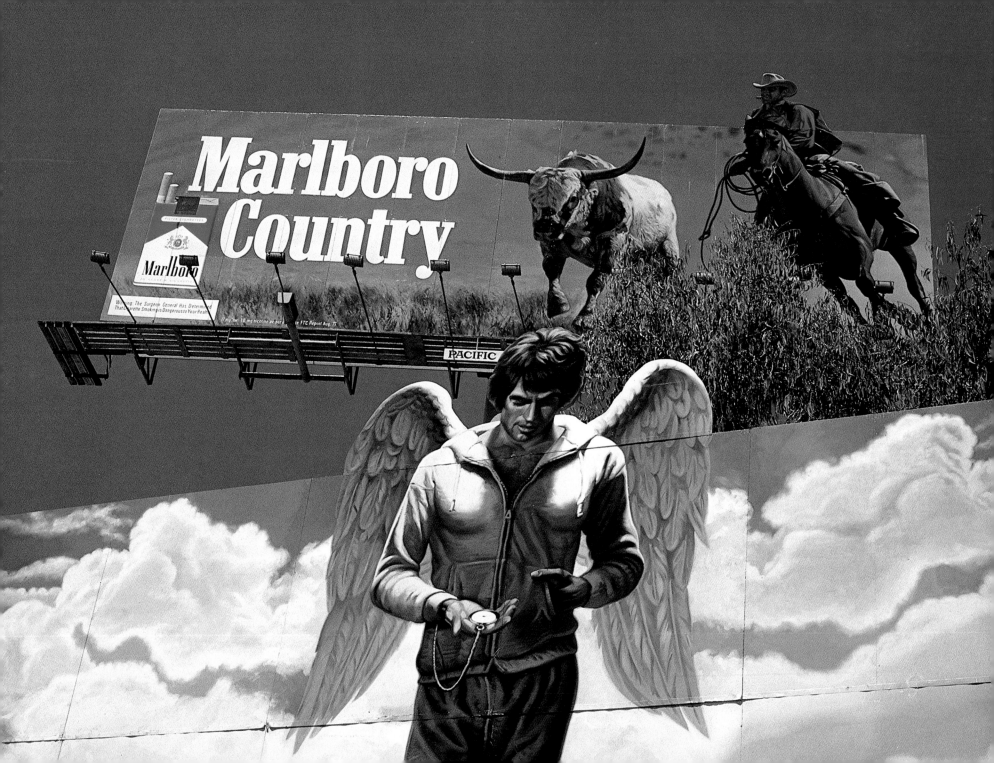

Crosby, Stills and Nash harmonize in the night sky above the Sunset Strip in Los Angeles. With its profusion of entertainment-industry billboards and low placement, the Strip is like a drive-through gallery, featuring a wide variety of art influences. In the entertainment industry, a board on the Strip is as much a symbol of success as it is an advertising device.

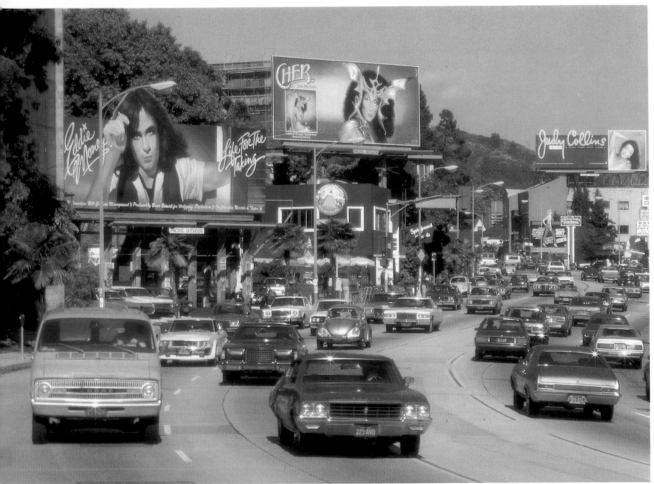

board art are found on the Sunset Strip in Los Angeles, which is not unusual since the entertainment industry pours so much money into the local economy. The area can be seen as a drive-in/drive-through gallery, a lesson in contemporary art to those who travel there. This collection of billboards is a twentieth century art experience, quick and to the point.

Over fifty examples of contemporary art are on twenty-four hour exhibition. The styles range from the exotic, to the erotic, surreal and absurd. Every art movement appears at one time or another. The driver, passing through this gallery, gets an uncurated look at what we hold important in our society. Here the viewer may see the world's largest collection of handpainted billboards or "spectaculars," as they are known in the trade. They still remain some of the most beautiful examples of the art of billboard painting. The same craftsmanship that once went into Renaissance murals is now expended on these giant commercial creations.

Unlike most billboard locations, the Sunset boards do not offer a long approach for subliminal absorption and heavy mix of traffic. The boards are piled one right next to another. Traffic in the area is composed of an elite but limited group, mostly tourists and people in the recording and film industry. Since the Sunset Strip billboards are some of the most expensive in the world for the

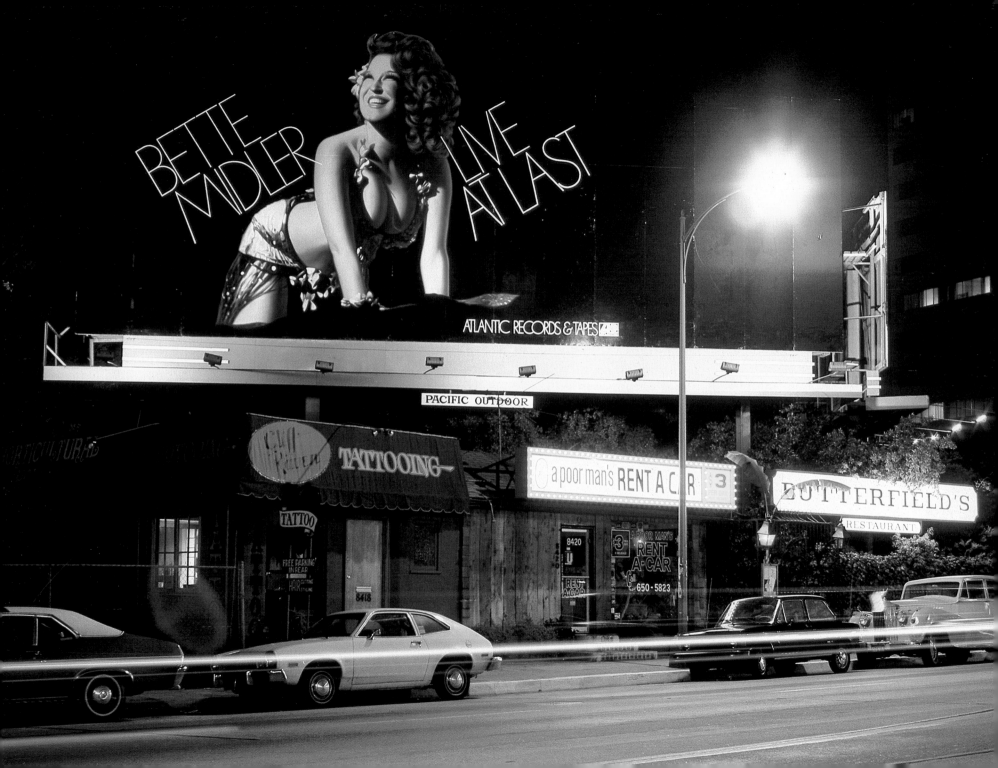

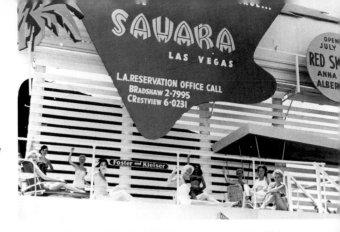

Beginning in 1953, with a board for the Hotel Sahara, complete with swimming pool and bathing beauties, the billboards of the Sunset Strip are among the most imaginative and innovative in the world.

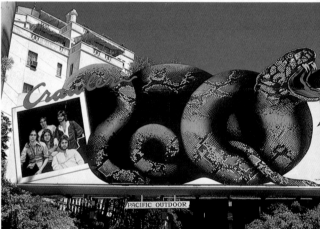

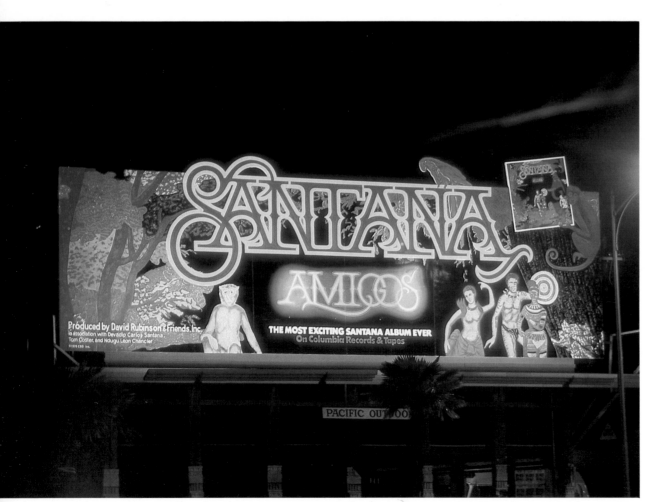

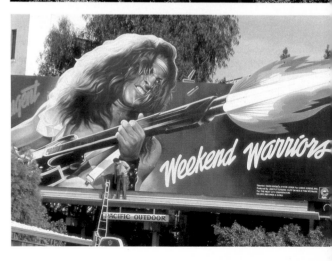

84

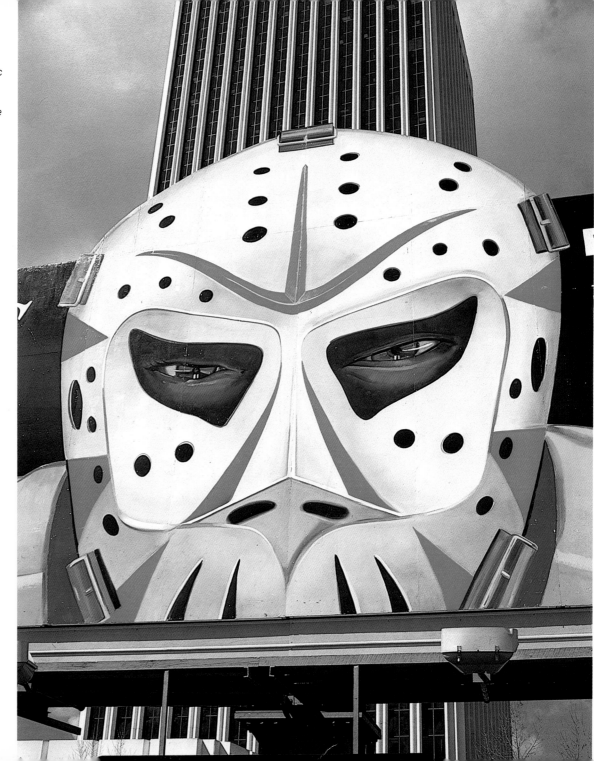

In the 1970s, sports events drew large attendances, rivaling the music and film industries for entertainment dollars. Here an ice hockey goalie with a menacing face mask glares down at the competition.

length of time they are up and the number of people who see them, it might appear as though they are a marketing mistake. But this is not the case: these billboards are carefully considered marketing tools. They are the entertainment industry speaking to itself—the importance of the audience justifies the expenditure.

The billboards of the Sunset Strip began to appear as far back as the 1920s, although at the time the road was a country lane. Art Nouveau and Art Deco images graced the road, and by the 1930s, it was covered with billboards for Del Monte, Ford and, of course, Coca Cola. By the 1940s, movies were beginning to advertise heavily, and in the 1950s, as the media turned its eyes toward the younger generations, the entertainment industry took over its present day monopoly of the area.

In 1953, the Hotel Sahara in Las Vegas commissioned one of the most elaborate billboards ever to be seen on the Strip. It contained a full-scale swimming pool, patio furniture, and even models in swimsuits. Crowds gathered around it constantly, and at the gala unveiling when the comedian Red Skelton jumped fully clothed into the water, the event gathered much media attention.

The Sahara billboard set a precedent on the Sunset Strip. Soon, a clever young agent, seeing the potential for publicity, put the image of his

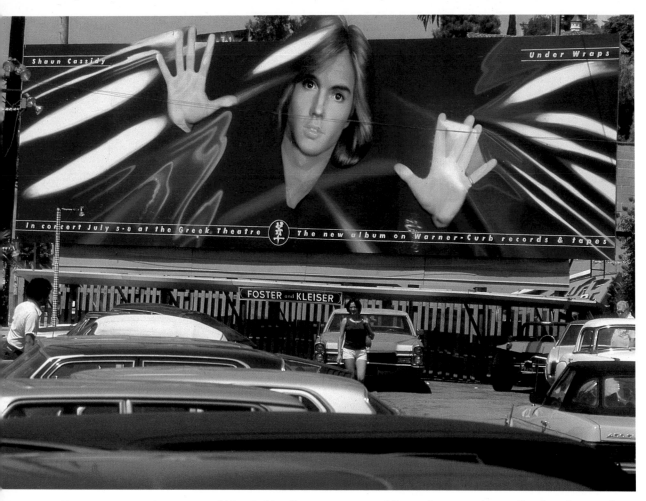

Creating an image is an important part of the star-making machinery. Promoters spend a great deal of time and money developing campaigns that will speak to a targeted segment of the population. Shaun Cassidy, appealing to the teen market, is kept under wraps, while the fashionable Olivia Newton-John competes for space and attention with other nearby boards. Pink Floyd takes a more basic approach to promoting its record ''Animals,'' and the rock group Wishbone Ash makes an equally bold, graphic statment.

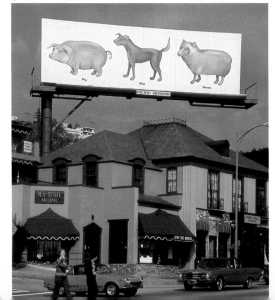

client, a young actress named Mamie Van Doren, on four billboards that bore the outline of her figure and the words ''Where's Mamie?'' From this she was besieged with offers, and enjoyed a short-lived popularity before fading into obscurity. In time, Mamie Van Doren's billboard was replaced with one for Frank Sinatra. Later billboards carried ads for the Beatles, David Bowie, Rod Stewart, and a never ending array of entertainers.

The Sunset boards are the pulse of the entertainment industry. Following these billboards

would permit anyone to monitor the changes in entertainment styles and trends. They often display inside jokes which can only be appreciated by fans and followers.

The boards occupy a privileged position and address a select audience—therefore, they are permitted greater risk and latitude than most examples of outdoor advertising. Sequential or teaser campaigns exemplify the different approach of the Sunset boards. These campaigns feature billboards whose messages change from

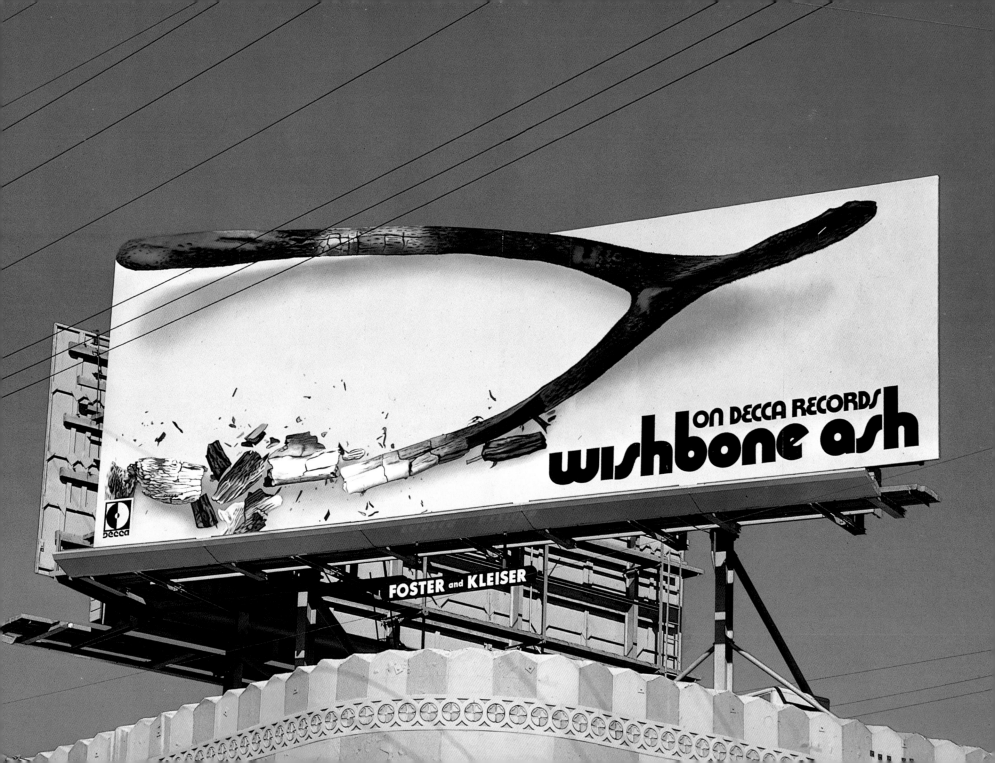

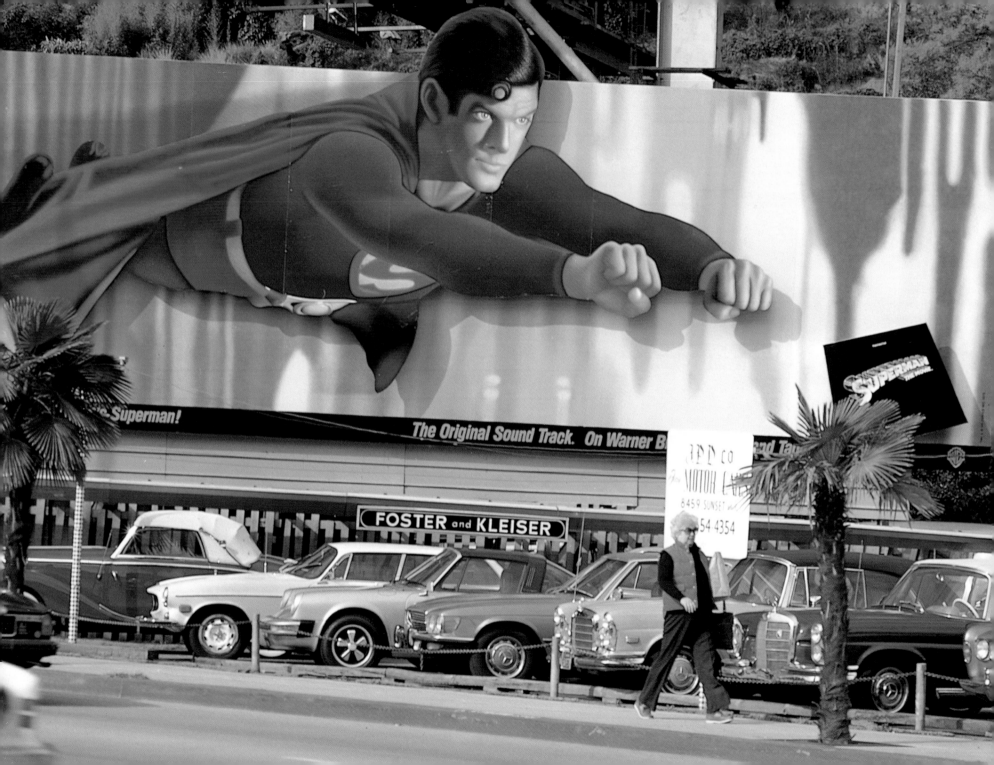

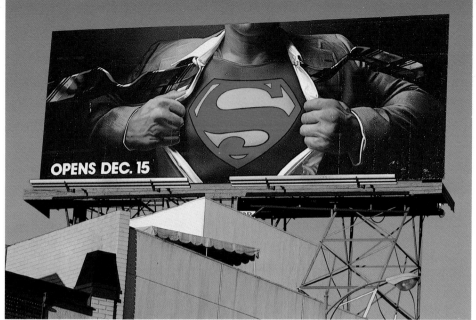

week to week with a gradual addition of fresh visual images and text. Bit by bit, more material is revealed, and the viewers' curiosity is piqued. An example of this approach is the billboard campaign for "Superman, The Movie." The first billboard bore only two hands opening a shirt to reveal the Superman logo. After several weeks a new billboard appeared featuring the full-length figure of Superman streaking across the Sunset Strip.

Because the Sunset Strip billboards are selling an abstract concept, one that can make or break a movie or a performer's image, it is not surprising that they are some of the most costly products the outdoor advertising companies put out. Their price tags range from $3,000 (if you are a new guitar player) to $12,000 (if you are an ex-Beatle) based on the nature of the embellishments. Sequins, neon, moving parts, extensions, inflatable balloons, and electronic devices can be added to the boards, which raise the price tags much higher.

The initial fee for the billboard includes several services—painting, placement, maintenance, rotation, repainting and the eventual dismantling—all of which can be paid for at one time. These commercial artworks are always team efforts, starting with the creativity of the movie or record company's art department, and passing along to the billboard painter's artistic interpretation.

Each painter will have evolved his own personal style in painting his 1,200 square feet of billboard, so no two hand-painted billboards will ever be alike. Especially since small nuances can be inadvertently added by each painter, the hair may be more blonde on one model, the eyes a little bluer on another, as the painter fantasizes over his plywood panels.

There is a hierarchy among billboard painters. Two different painters are often hired to fulfill the needs of one board, the more disciplined artist doing the focused work, and the background going to a more spontaneous painter. A pictorial painter may apprentice for up to eight years before being able to join the union, but even after joining an artist's salary and position rests solely on his talent.

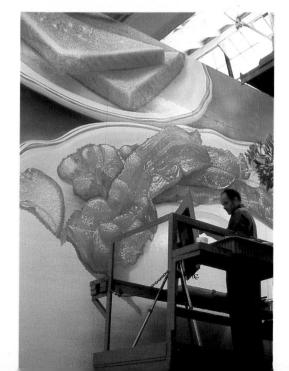

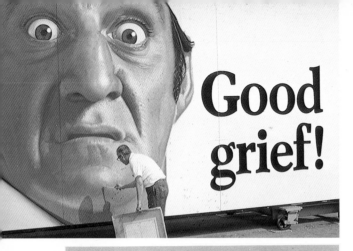

Good grief!

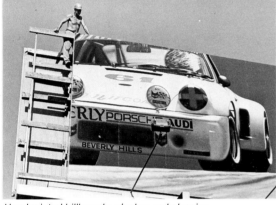

Handpainted billboards, sleeker and glossier than printed posters, are made of removable plywood sections which are hoisted up and attached to the billboard frame. The lithographic posters are simply pasted and brushed onto an existing structure.

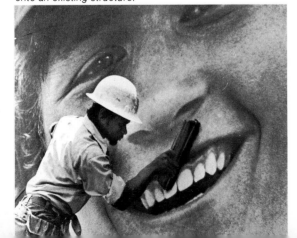

With all the technological innovations of commercial art, certain methods still prove the fastest and most economical for creating large images. The pounce pattern technique was used by painters to ready church ceilings and walls for their brushstrokes as far back as the late Middle Ages and the Renaissance and is still the best method. Of course, certain electrical refinements have been added to facilitate the entire process.

To begin with, the original artwork is put on glass slides and projected onto a huge, white paper, cut to the exact size of the billboard. As a pattern, to minimize any distortion, two slides and two projectors are used, one for each half of the projected image. The paper is stretched over a grounded copper mesh screen: then, with the aid of electrified charcoal pencils, the major masses are copied on. Wherever the pencil touches the screen, a 500-volt electric arc results; thousands of tiny burn holes or "pounce points" are created in this fashion which corresponds to the lines of the projected image.

The finished pounce pattern is a giant stencil which serves as a guide map for the artist. This pattern is then moved into the plant's studio, where the plywood panels are assembled on racks, and the pounce pattern attached. Then workers hit the pattern with bags full of charcoal dust, which is forced through each of the perforations in the paper, creating a totally accurate and detailed delineation of the original design.

Then the painters mount a motorized scaffolding and, working from the pounce pattern and a quality color print of the original art, give form to the master design, reproducing the colors and textures of the original. To insure fidelity, they work with the aid of a reducing glass, which allows them to view their work as if at a distance. Weather resistant, oil-based paints are used; even so, most contracts specify repainting every four months as part of the price tag. Finally, varnish is brushed on, not only to protect the pigments from weathering, but to enhance the color contrast and highlights and provide a glossy finish.

It usually takes between five and ten days for a handpainted billboard to reach completion. Although billboard companies require artwork to be submitted at least sixty days in advance, there are always some companies with last minute demands.

There are two kinds of billboards most common today; the hand-painted billboard, and the printed poster panel. Hand-painted billboards are most economical when only a few are needed. Because of their larger size, they are much harder to transport, but they have a luminous quality, which, in combination with their size, sets them apart. They are the billboard of choice when a company wants their product to have that special look. In using these "spectaculars," a

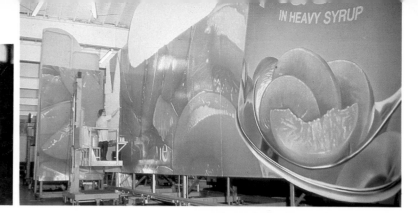

small local advertiser can attain the visual stature of a large, major national advertiser.

The poster panel, which is slightly smaller than the hand-painted version, is far more common. Lithographic sheets are printed ahead of time by machine and then posted. Large promotions couldn't get along without them. Think of the thousands of Marlboro men waiting in the foliage along roads and highways.

When any hand-painted billboard's showing is over, it is returned to the painting studio and white washed. The plywood sections are disassembled and the billboard is ready for a new reincarnation. (After paying a base rate, for an additional amount of money the advertiser might buy his billboard intact, in which case he must pay for the current cost of the plywood.) Posted paper billboards, on the other hand, are simply pasted over with a new message directly on the site.

Up close, within a range of five or ten feet, the paint strokes of outdoor art are loose enough to be compared to the Abstract Expressionists' work. Overly precise images would not carry nearly as well over great distances. The contrasts are deliberately accentuated; the colors are exaggerated. Looked at from a few feet away, the images would dissolve into separate washes of color. But seen at a distance, and for only a few seconds, from the vantage point of a car speed-

This series of pictures (left and above) traces the progression of the handpainted process from original scale design to the completed and installed billboard. When a board's showing time is over, it is whitewashed and made ready for a new message.

A Van Dyke masterpiece is re-created in billboard dimensions to illustrate a campaign promoting the "fine art" of banking (below).

Borrowing an idea from the conceptual artist Christo, a billboard promoting Rick Wakeman is wrapped in red cloth. This was a highly successful teaser campaign and the board aroused a great deal of curiosity before its message was unveiled. Another well-packaged campaign was Paul Anka's billboard, which was an actual three-dimensional box wrapped with a rope.

ing past, the eye's impression combines with what the mind already knows, and focuses the image into something immediately recognizable.

These innovations in the world of billboard advertising were the outcome of decades of new developments in the field of fine art. In the art world, in both traditional painting and sculpture, changes had been occurring slowly since the turn of the century, but with great impact. Gradually, a daring step was taking place: artists were abandoning all representational efforts.

During the 1800s, Impressionism had brought a new concept of painting; a canvas could now be looked *at* as a patchwork of colored pigments, not *through*, as a traditional window into another world. And perhaps the advances of the photographic medium were also forcing artists to reevaluate their role in representing some-

thing that could be perfectly reproduced by film.

Cubism, which had started as far back as 1910 with Picasso and Braque, had easily left its mark on contemporary advertising, with faceted and angled shapes and abstractions appearing in lettering and imagery. By the 1930s, Mondrian had completely abandoned even faceted imagery for total abstraction, restricted to horizontal and vertical lines and the three primary hues.

In the 1950s, Abstract Expressionism—another venture into nonrepresentational art—replaced the classic painterly mode with canvases featuring the paint itself, with its very colors and textures, as the subject. And in the 60s, Pop Art made its humorous statement as a backlash to the extreme nonrepresentational period of the fifties, parodying the commonplace and commercial objects of everyday life.

In the early 1970s, a new art movement came into the foreground, one that was tremendously influenced by commercial billboard art. The painters of this school called themselves Photorealists or Super Realists. Their work, reflecting the perfection of photography and the *gigantisme* of billboards, gave a new and more detailed significance and dimension to painting. But the "reality" of the Photorealists represented nature differently. It was industrial, flat and commercial, lacking the luster of realist paintings done in the nineteenth century.

At first glance, it appeared that Photorealism was a relative of the Pop movement from the 60s, since both trends dealt with recognizable objects. But the Pop artist's conception of the world was greatly simplified, almost to the level of a cartoon. Photorealism, on the other hand, was

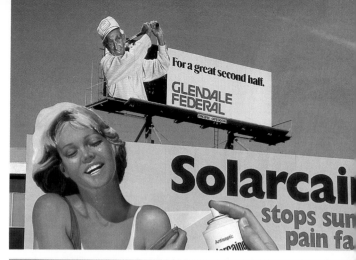

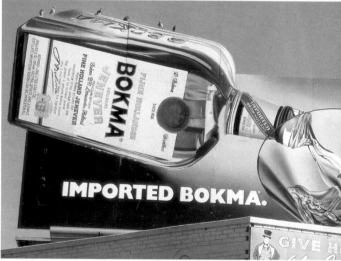

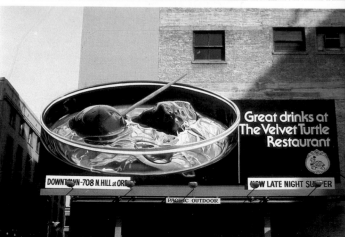

far more involved with details, such as reflections on glass, or shadows, and made statements on canvas that seemed closer to commercial art than Pop.

Photorealism was the final, inevitable link between the fine arts and commercial art, bringing them within the same boundaries. The canvases of the Photorealists portrayed the modern environment of giant billboard images, barren industrial landscapes, and glittering shop windows. The pedestrian and billboard viewer of the 1970s was used to seeing giant bottles of liquor with gleaming glass reflections and every shadow and nuance painted in detail. It was a natural step for the advertising environment to affect contemporary painters of the period.

Photorealism's painters usually worked from actual photographs, much as the Pop artists did, but they expressed a more rigid and humorless point of view. Photorealist painters were so true to detail that they devalued the image to some extent by turning it into a giant postcard reproduction.

Painters like Estes, Salt, Bechtel, and Goings approached the object realistically, painting cars with complex chrome reflections, and everyday street scenes of mundane neighborhoods. Cottingham produced mirror-finish marquees in paintings that mimic the commercialism of contemporary street signage. Bottles

of Tanqueray Gin seem little more than billboard images in the paintings of Fish.

Billboards still continue to employ many of the characteristics associated with Pop Art: simplification, objects floating in open space, unattached, without gravity. These techniques are perfectly suited to the billboard and the speed at which it must be read. And during the seventies, billboards looked more and more like large photorealist paintings as well, with images detailed in painstaking exactitude, as though they had been originally fabricated on that giant scale. Every drip rolls down the side of the liquor bottle as the ice glistens and melts in the heat of the sun hitting the billboard.

Minimal and Conceptual art has also been an important factor in the art of the seventies and the eighties, as its influence is just now beginning to have an impact on billboard art. Minimalism is an art trend that did away with all but the most primary elements of an object, leaving an essential aspect of, for example, the object's color, or the most pronounced line of its silhouette.

Conceptualism pushed even further into abstraction and brought out visual "thoughts" that often times had no definite volume or characteristic art qualities. A piece of string on a wall, moving from point A to point B, could be an artist's conceptualization of an idea concerning time, movement, or space.

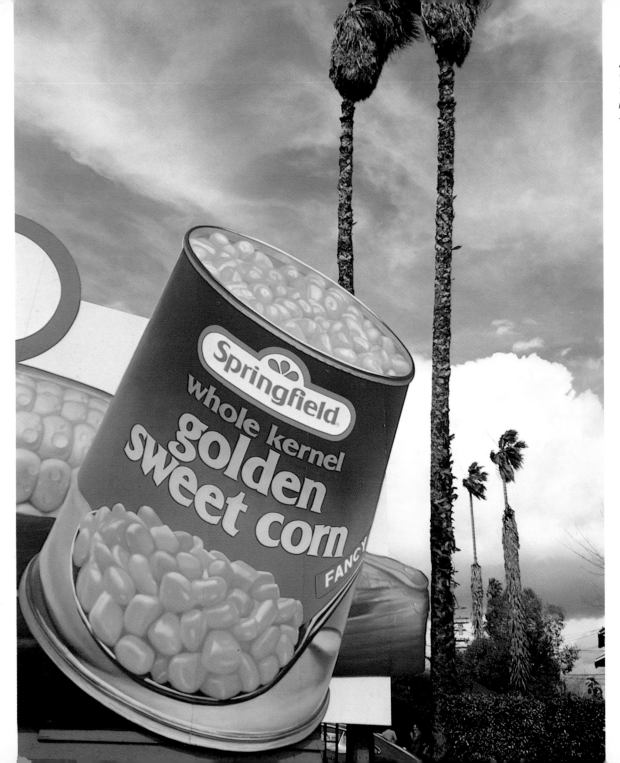

Appealing fresh fruits and vegetables are often used to promote the canned product, as in this ad for Springfield corn.

The Minimalist trend has affected billboard art by allowing commercial artists on occasion, to take products down to their most important or recognizable elements, and represent them through a mere word or image, one that will make the viewer think immediately of the product. Conceptualism is not well suited to billboard art, because of its esotericism, but it will probably leave its own mark by the end of the 1980s.

Throughout the 1970s, Photorealism was in the vanguard of the traditional arts. But at the beginning of the 1980s, we are left without a single school or movement in the foreground of the art world; painting now shares equal status with less traditional artistic modes. New artists are involved in non-traditional art fields, including television and theater, and the juxtaposition of these fields with traditional art forms. Multimedia art productions are the result of these combinations.

Cultural developments in the 1970s also had a hand in changing billboard art. Punk rock and the New Wave movement it spawned left their mark on advertising in several ways, affecting layout format and the use of color. Punk, a type of musical revolt against established culture, expressed its rebellious, anarchic message through forms popular in the 1950s.

The effect on layout in illustrations and billboard design was to introduce a deliberate ran-

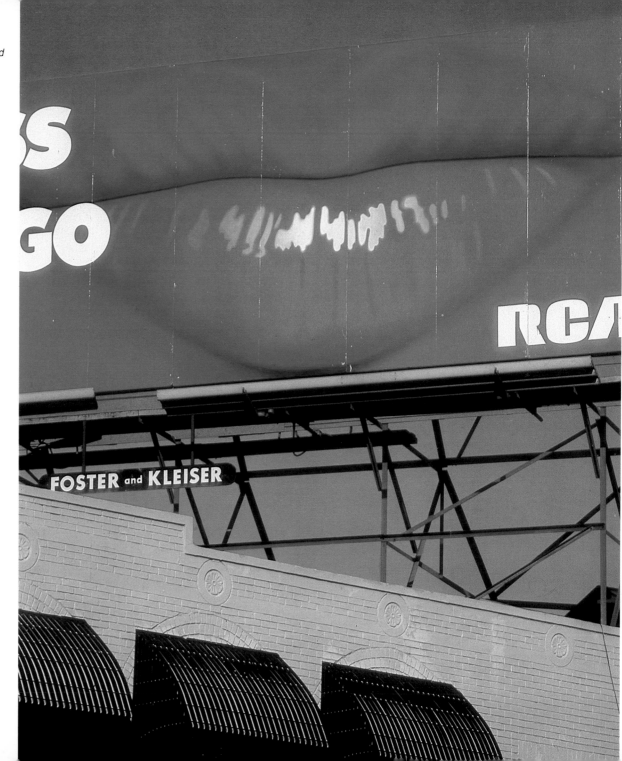

domness not seen since that decade. Once again, the linear aspect became important: figures, objects and letters were set at angles to one another for a harsh, disjointed impression, making them seem to jump off the page.

In the face of growing concern over the environment, signage laws throughout the world have become increasingly more stringent in the 1970s and will continue in this direction in the 1980s. Many people, confused by the different kinds of signage in the environment, do not realize that the outdoor industry is the main force behind the standardization of billboards and independent signs. They have, after all, a great deal to gain by placing higher quality, neatly conforming signage into both new and old cities, doing away with misplaced, tattered and ugly boards, and gaining community support in the process.

"On premise" or "on site" signs, as they are called, meant to advertise a business, and installed on the property of that business—on the roof for example—are placed independently and are often not required to conform to many laws. Because of this condition, older cities may contain garish strips adorned with ugly signage, unregulated and uncared for. Independent signage put up without the aid of professionals in the industry can also go from bad to worse if the local inhabitants are without qualms—or city legislation.

Studies indicate that usually a mere 10 per-

Ads posted on street furniture, like these bus-stop benches in Hollywood (left) and this utility pole in Zürich (below), attempt to gain the city dweller's attention.

cent of all signs in a city are billboards. The other 90 percent of signs in commercial/industrial areas are overwhelmingly business or store identification signs, called "on site" signs. Thousands of street and traffic signs, posters for candidates running for office, organizations with commercial and noncommercial messages, compete for the pedestrian's attention.

Utility poles, overhead wires, and street furniture—bus benches, kiosks—as well as mailboxes, trash containers, and fire alarm boxes, all need to be considered in an attempt to clean up the cities. But often such a program seems too all-encompassing for a city council to deal with, so they turn on billboards, thinking this will help to alleviate the situation.

In the United States, the federal government passed the Highway Beautification Act in 1965 to help standardize billboards along highways. The government had no intention of banning billboards. It wished to regulate their size, spacing, lighting, and quality. Many older and badly maintained boards were taken down, as well as those originally placed in residential areas.

In setting standards for billboards, in both zoned and unzoned areas designated as commercial, the criteria followed were designed to assist the advertising industry in achieving an orderly and effective development of outdoor ads. There

are some smaller communities, residential in character, that prefer to live at present without signage, especially if they are famous for their natural beauty. Carmel, California and Aspen, Colorado, are two good examples of towns which have imposed this restriction. The majority of outdoor agencies agree with this viewpoint, since these areas are not major metropolitan markets. And in most instances, laws restricting on-site signs complete more general efforts at environmentally conscious legislation.

Any billboard in the United States that is removed through legislation is paid for with just compensation, which is figured from a schedule of appraised market values. Some states, like Hawaii, have completely banned billboards, but this procedure is costly in the extreme, since compensation must be made for future income on billboards as well. And each state must rule on the constitutionality of putting a legitimate commercial enterprise out of business. Many feel this to be a violation of First Amendment rights.

In addition, there is the question of eliminating revenue gained by businesses through having billboards on their property. For many property owners, a billboard on their land or building is a source of income which assists in paying their ever-increasing property taxes.

Investigations into outdoor advertising revenues and their contribution to the market value of

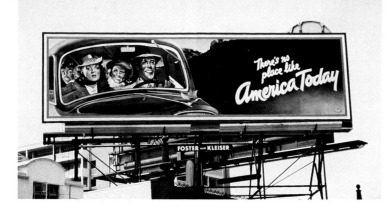

A billboard for Curtis Mayfield re-creates the classic Margaret Bourke-White photo of Louisiana flood victims (see page 37), which has come to typify some of the contradictions in the American way of life.

This ad for the movie "Young Frankenstein," painted directly on the Playboy Building, was the largest billboard ever to appear on the Sunset Strip.

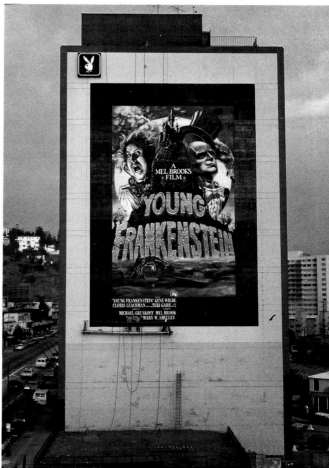

a commercial or industrial property indicate that no economic disadvantages accompany a billboard's presence. A majority of the costliest signage is found on the more expensive commercial property. Although a billboard is not suitable for all parcels of land, most property owners take the impact on tenants, neighbors, and the physical environment into consideration.

Considerations of safety must come into play when determining appropriate locations and structures for billboards. While people drive, their attention continually shifts from one point to another as they discover all the visual information available. Of course, the more active the traffic, the less time there is for the driver to view nonessential items. But drivers tend to use peripheral vision as well, catching objects from the sides of their eyes. In this manner, the driver's vision can be focused either directly on the road or on buildings and signage to the side.

Since eye movement is a normal response, one designed to keep the individual awake and alert, billboards are a source of the visual stimulation which actually protects the driver. In a study undertaken to determine if billboards could cause traffic accidents, the records of the Department of Traffic Safety and the Department of Transportation in California were studied for one year. The computers for these agencies contained descriptions of all accidents, including greatly detailed

accounts of distractions, confusions, and other driver conditions and errors. The computer results reported no listing of billboards as a factor in these accidents; they were not enough of a distraction to pose a safety hazard.

When show-business advertisers asked for billboards of supersized dimensions (over 100 feet long), some using live models, others with sound (talking billboards), outdoor companies encouraged ordinances specifically prohibiting such embellishments, which are clearly against public welfare and safety. In one case, the City Attorney was forced to step in and block the continuance of a huge billboard constructed by a motion picture studio. The billboard was a dangerous distraction, because it incorporated an actual movie screen into its structure.

While protecting the environment and maintaining traffic safety remain paramount, unless there is a drastic change in the economy billboards are here to stay. We cannot lose sight of the fact that outdoor advertising is an integral part of commerce. Billboards represent an established segment of the economy in most nations, and a major source of revenue.

The ability of off-site billboards to communicate to huge, mobile audiences at the lowest cost-per-thousand makes it a selling tool vital to many advertising agencies and their clients. On a national basis, outdoor ads deliver an audience at

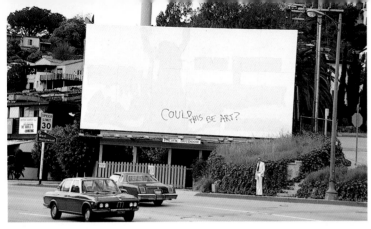

In the 1970s, it was often difficult to distinguish fine art billboards from commercial messages. An anonymous graffiti artist poses a rhetorical question on a blank board, while Cat Stevens presents a picture of paradise that doesn't have a single word of advertising copy (left).

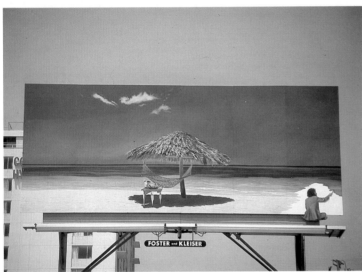

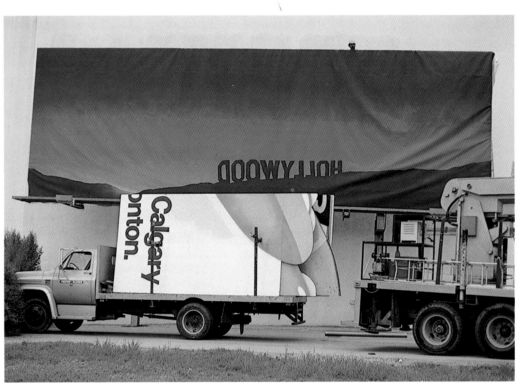

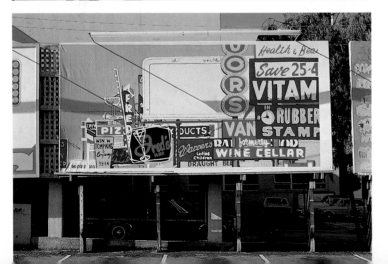

A San Francisco painter takes the billboard a step further with a sign within a sign (left), and artist Ed Ruscha casts a whimsical glance at the Hollywood sign as if viewed from behind (above).

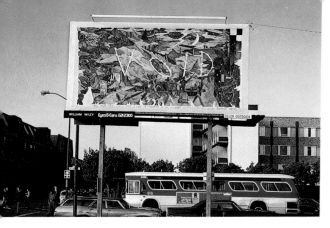

less than 30¢ per thousand persons. This figure compares to $1 to $3 for network television, and as much as $50 per thousand for certain magazines. Advertisers must think in terms of gross rating points (GRPs) and how frequently they can reach into our lives with their products. Approximately five hundred strategically placed billboards will rate a 100 percent GRP; which means that an average individual will be exposed to the product many times over a thirty day period. Of course, traveling salespeople may be exposed to an overdose of advertising, and people who do not drive may never be urged to buy the product at all.

Outdoor advertising, because it is such an efficient medium in terms of reaching its audience, allows even a small company to achieve advertising saturation within its budget. The simple but striking messages of the medium help to create the sort of consumer awareness and response most companies seek.

The effectiveness of billboard advertising cannot be in doubt. In a recent American advertising study, a research firm asked a random five hundred adults if they knew the name of the 30th President of the United States. Only 4 percent knew the answer. During the next thirty days, 170 billboards appeared. They read "Calvin Coolidge was our 30th President." A month later another five hundred people were polled; but this time, 39.8 percent knew the answer.

Artist William T. Wiley paints a metaphoric interpretation of the word "Void," and Rick Griffin, well known for his psychedelic poster art of the 1960s, presents his "Imperial Message."

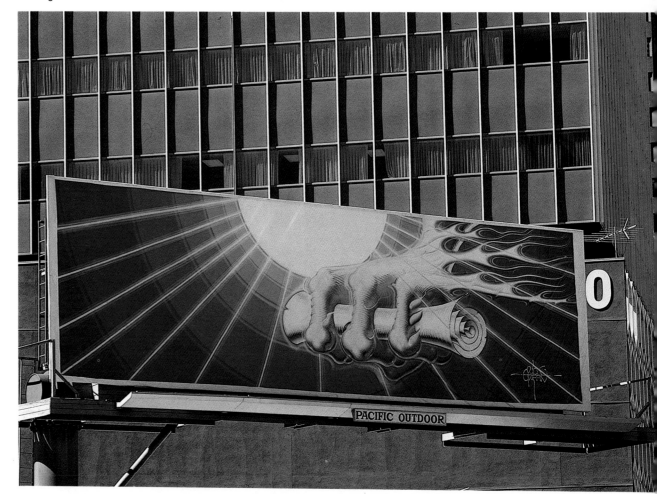

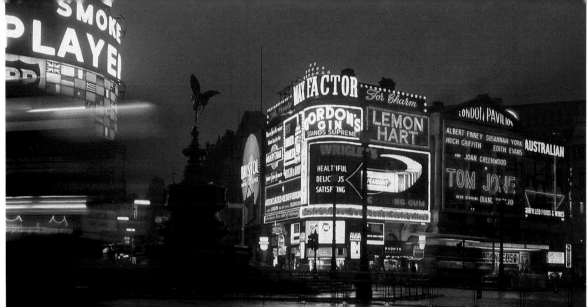

Billboards and light spectaculars add glamour and excitement to vital areas in all large cities of the world. Their color and vibrancy are an important part of the urban landscape, as seen in these night shots of London and Tokyo.

Apart from other considerations, such as cost effectiveness, an aesthetic criterion for judging signage is in order. It is important to consider the glamorous character billboards add to certain areas of the world. London's Picadilly Circus, New York's Times Square, Tokyo's Ginza, the Strip in Las Vegas, and Sunset Boulevard in Los Angeles —all these places have a special attraction, an enchantment. The excitement generated by these billboards and neon media art forms have made each area uniquely famous.

One example of where signage creates a carnival atmosphere is the Strip in Las Vegas. This area contains a number of excellent billboards as well as an overwhelming number of business signs. Neon and wooden structures conforming to no uniform standards vie with one another in gaudy holiday profusion, a visual bombardment which is often bewildering to the viewer. This situation lends Las Vegas much of its famous festive atmosphere

What is perhaps best of all, commercial billboards can create art experiences that offer creative composition of shapes and color relationships to the average viewer. Billboards offer a popular art form which, unlike the art on display in museums, is not taken out of context or removed from everyday life. Instead, the image is put back into the environment, where it belongs, and where it is more truly an expression of average people.

Las Vegas has little in the way of signage legislation or restriction; the abundance and variety of signs that result add to the carnival-like atmosphere that is part of this all-night city's attraction.

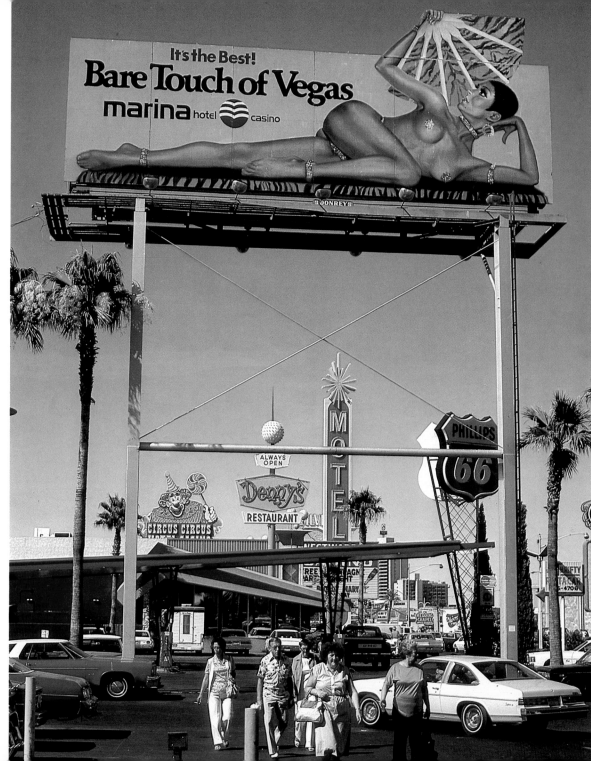

5

The 80s and Future Trends

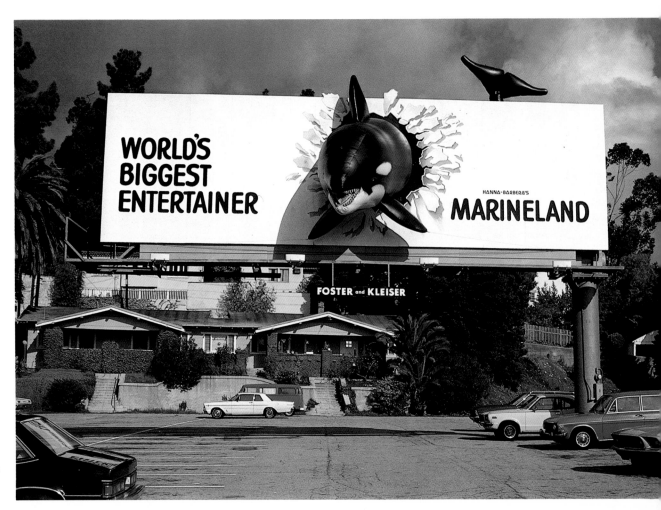

The trend toward three-dimensional realism has led to the creation of the inflatable bill-board. Orca, Marineland's killer whale, is made of stitched nylon which is inflated by the use of an electric fan and is strong enough to sustain small punctures without collapsing.

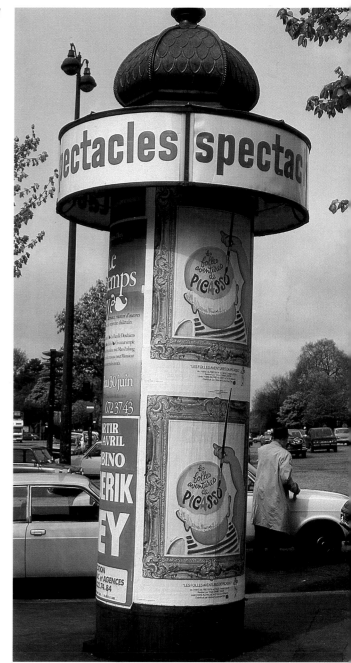

Although the kiosk is widely used in European cities, it is only beginning to appear in urban centers throughout the United States. With more pedestrian malls and less dependence on cars, however, the kiosk and other variations of poster columns will become more common.

Billboards change and diversify to meet the needs of the public they address, as any medium must. Technological innovations in the structure and function of billboards have kept pace with changes in visual information and design. Early wooden A-frame structures gave way to wooden telephone pole standards, then to square steel I-beam construction, and finally to giant circular steel tubing posted in the ground. In the 1980s, the simplified version of a billboard standard is a large steel tube with the actual sign either cantilevered off to one side (so that the entire structure describes an L shape) or else positioned in the traditional manner on the center of its base.

In the future, the billboard structure could follow a format presently being used in parts of the United States. The concept is based on a totally removable and salvageable board, one that can be repositioned on a new site, leaving nothing behind. A large steel pole, octagonally shaped and used as the base of the board, is set into a hole in the ground at a new location. The top of the pole is left open, awaiting the actual one- or two-sided billboard. Meanwhile, the outdoor advertising company constructs a single- or double-sided billboard, arranges the panel units and sets them into place on a billboard facade. Instead of trucking the sections out to the site to be lifted one at a time and installed there, they now proceed to hoist the billboard frame onto a boom truck, complete with finished message intact.

The billboard is transported in its entirety onto the site. The pre-assembled board is then boomed up above the waiting pole and attached to it. This process is much faster, requires fewer workers, and all maintenance of the board panels and frame can be done in the plant instead of the open air.

Of course, the real attractiveness of this new concept in installation is the idea of easy relocation. The billboard can be simply lifted out of its hole by a crane. The hole is filled, and the structure can be placed into a new environment. Given the frequent changes of signage laws, and the equally rapid changes in ownership of commercial property, it makes sense to have a clean, movable billboard. The new octagonal board fulfills this need.

Innovations in billboard advertising in the sixties and seventies tended towards elaborate electronic additions displaying computerized configurations of some sort, or a simple restyling of the structural frame of those billboards already in existence. However, because of legislation banning billboards in many areas where they once stood, this has caused outdoor advertising to develop increasingly creative, innovative approaches.

There will be many inventive technological

The low tar cigarette.

SILK
CUT

LOW TAR
H.M. Government Health Departments. WARNING: CIGARETTES CAN SERIOUSLY DAMAGE YOUR HEALTH.

UNDERGROUND

Ice Cream & Cigarettes

HOTELS

Minear Munday

EUROPE
AND
OVERSEAS RESERVATIONS
FREE SERVICE FOR LONDON LONDON
AND
PROVINCIAL

This back-lit board in London's Victoria Station is made of painted translucent vinyl which shines with an inner glow. At night or in darkened areas, the colors are more luminous than on externally lit boards.

A billboard placed on Indian-owned land protests injustices against the Native Americans. English billboards remind viewers of government intrusion and needed educational reform.

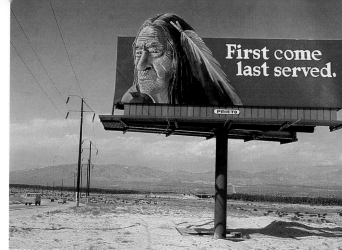

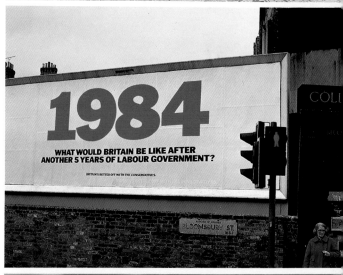

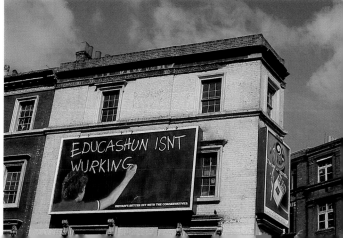

possibilities for outdoor advertising implemented in the upcoming decades. The success of billboards depends largely upon their capacity to grab the viewer's attention, so billboard companies are always open to new ideas.

Specially designed urban walls, sidewalk kiosks, kinetic posters, and city-related signage are all being explored. One interesting answer to the question of a billboard's usefulness in the urban environment is a billboard constructed not merely as an advertising display, but as a functional urban unit housing useful facilities. Other ideas that are being tested and perfected are inflatable billboards, computers that paint and solar-powered, holographic, laser-equipped, and panographic boards, which are lit from inside.

Urban walls can be used in a new way, by making a standard poster a part of a permanent supergraphic wall mural. These wall murals could have unusual geometric shapes around them, treating the poster as only one part in a larger aesthetic display.

In the United States the kiosk—a European tradition—is being adapted to lend shelter and provide a variety of uses for passing pedestrians. The three-sided kiosk can be built next to the ground, or be erected on poles over bus benches to protect waiting passengers from the elements.

Changes in transportation will occur increasingly in the 1980s. With the gasoline short-

age, the re-utilization of urban areas, the growth of suburban malls and the advent of rapid transit, smaller billboard displays aimed at pedestrians will become more popular in the United States.

A standardized, environmentally acceptable structure, well suited to the needs of pedestrians and the available space in plazas and malls, is still in the planning stages. Besides providing shelter for bus benches, these structures could accommodate pay phones, emergency communications, maps, display cases, and other service equipment.

Recently, smaller posters and billboards have been appearing in inner-city urban areas where space is at a premium. Many of these boards are well-designed units standing on a steel post approximately fifteen feet off the ground, and measuring six feet high by twelve feet wide with an eight-sheet poster paper. They are based on a new concept in outdoor advertising.

The effectiveness of the height, size and placement of large, thirty-sheet billboards is being closely studied by many companies. Some feel that reducing the billboard in size as well as lowering it to eye level can have a major impact on the viewers ability to see and remember the billboard message. This is an unusual premise, since established beliefs concerning billboard advertising are that the bigger the message, the better.

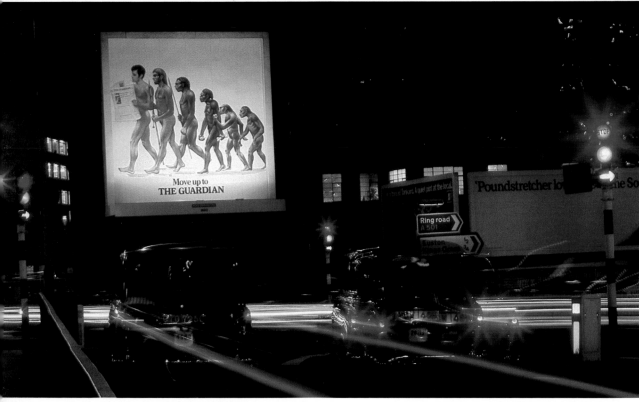

A billboard in England traces the ascent of man.

However, Telecom of New Jersey has undertaken studies indicating that very large, elevated billboards may be less effective. According to their findings, drivers rarely look beyond a few blocks ahead of their immediate view or at items more than twenty-five feet above street level during the last two hundred feet of their approach to a sign. Large, elevated thirty-sheet posters were also found to disappear from the view of someone inside a car within the last eighty feet of approach. This would indicate that smaller signs located at eye level might be more effective than larger displays. The old Burma Shave signs, so well read along the United States highways, would be a good example (although they are small by today's standards) of eye-level signage.

Today, city planners and urban designers more easily accept these smaller billboards since they are constructed for a clean, contemporary look. And the internally illuminated boards, made of white acrylic with a Mylar overlay that carries the message, lend another sidewalk light source to darkened areas.

A restyling of bigger billboards might also include a larger-than-normal base that would function as a serviceable unit. For example, the idea of a clamshell-shaped billboard structure has been proposed in some areas. The clamshell board would be turned on its side—a double-sided billboard that bends at the corners, so that both faces take on a curved, convex surface, with the entire arrangement sitting on the new, broad-

ened base. With its curved edges the display can be seen in more directions at once, and the integrated lighting system keeps it from looking cluttered.

The base of the clamshell board might be tailored to particular locations. As a standardized module with services or amenities built into it directly, it would become a recognizable, functional fixture, much like a telephone booth. Shelter, restrooms, phones, and other urban necessities could be easily identified as features housed in these modular systems. The concept of modular amenity supports to billboards of the future would be a welcome addition to many lonely areas within urban neighborhoods.

Kinetic posters are another unique idea used infrequently over the last twenty years. Standard poster sheets are printed with three or four messages in segments that measure the width of a square column. The column might be one-foot wide on a side; the message is printed so that it wraps around the column. As the viewer approaches from different angles, he reads the different messages. This kind of display can remain static—the viewer brings the kinetic force to bear by walking around it—or the columns can be turned electronically to bring the different ads into view. It can present a sequential message or a series of separate messages. The kinetic board, using large pylons can present messages in tight

106

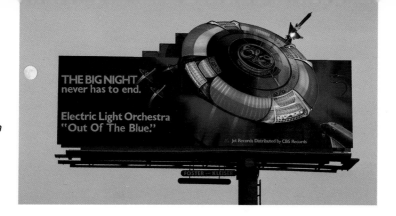

The rock group Electric Light Orchestra created one of the most complex and expensive billboards ever made. The board incorporated a fiberglass attachment complete with rotating light circuitry to create the effect of a hovering space craft.

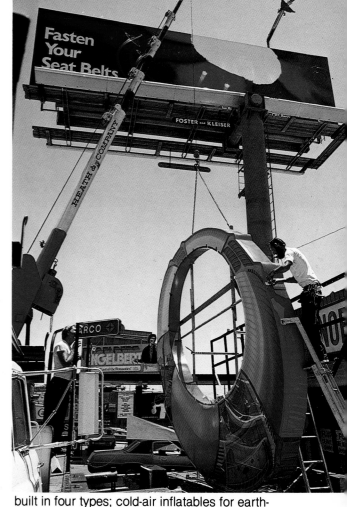

urban locations, such as plazas, where regular frontal approaches are not possible.

Kinetic surfaces are billboards with two or three separate posters mounted on a column that either remains stationary or revolves electronically. A particular type of kinetic display involves a folded screen, similar to a corrugated surface, with messages on either side. The viewer moves past and different messages appear.

Unfortunately, possibilities for more publicly oriented billboard presentations are not being explored in depth by cities, except when billboard companies donate space to public service organizations. The city itself, however, could become an advertiser with helpful messages aimed towards visitors, as well as toward the local inhabitants. Welcoming signs could be erected at main entrances and thoroughfares into cities. Since billboards are typically used as huge captioned photographs, pictures of artwork or crafts pieces could attract onlookers to galleries, museums, fairs, and special events.

Aerial views on billboards could give information about parts of the city or what lay ahead on the road, and could help direct traffic and make traveling easier. Already, many cities use the electric signage blackboard at critical intersections, whose messages flash and change to accommodate new data about the upcoming area. And since billboard locations line the

streets, the idea of providing the driver with a billboard preview of an upcoming vista or landmark might help in negotiating unknown areas. A photograph of a recognizable structure might be captioned "You will be there in five minutes." These service billboards would lead people to many important areas of the city through a simple diagrammatic approach.

For years, advertisers have tried to create a more three-dimensional quality in their billboards through the use of many additional components. Apart from the traditional painting technique of *trompe l'oeil*, the French phrase for "fooling the eye," and some interesting use of perspective painting, not much has been discovered that would embue billboards with a truly sculptural effect. Animation through moving parts, fluorescent paints and sequins that move in the wind all helped, but not until the advent of inflatables did it become economically feasible to construct billboards in three dimensions.

The three-dimensional billboard—an innovation in outdoor advertising—has been achieved through the use of inflatable objects attached to the traditional billboard. These larger-than-life inflatable advertising displays can be used to recreate everything from the world's largest tequila bottle to Marineland's Orca, the killer whale. They transcend mere advertising to become environmental sculpture. Currently, inflatables are

built in four types; cold-air inflatables for earthbound objects; helium inflatables for airborne, blimp-like displays; a hot-air variety for free-flying objects; and cold-air structures attached to the face of billboards.

These three-dimensional beer cans and airplanes are made of very strong vinyl-coated nylon, similar to the material used in truck tarpaulins and awnings. Virtually tearproof, this material retains its color for up to five years against the ultraviolet rays of the sun. The objects are inflated by small fans operating on the billboard's 110-volt

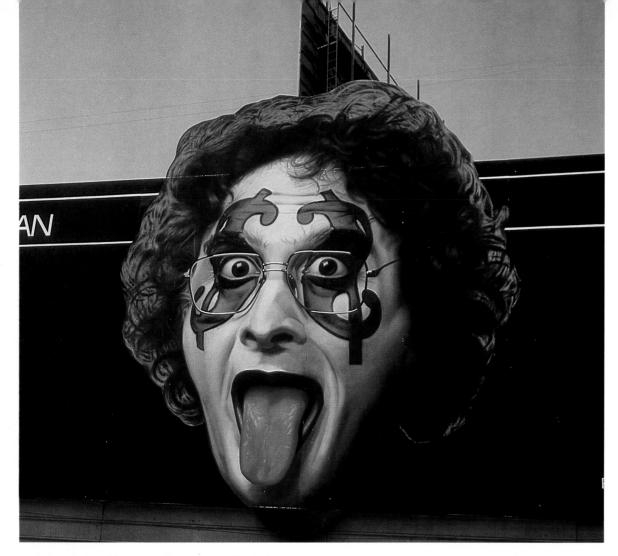

the 3M Company in the United States. It involves a painting computer that can recreate an original art work, in billboard dimensions, without the usual graininess or loss of detail found in regular photographic blow-up.

These "Scanamurals," as the 3M Company calls them, are large format, full-color graphics, painted electronically by the computer process working from camera-sized photographic transparencies or prints. Poster paper can be used as a medium for the process, as well as fabrics and vinyl.

The painting computer has three major components that allow it to work its artistry: a color scanner, a computer, and a large drum on which the painting is reproduced. Paper can be wrapped around the drum, while the original transparency is wrapped around the scanner on a similar, but much smaller scale. The scanner rotates at the exact same speed as the large printing drum; a light beam reads the transparency, converting color and density to electrical signals. These are interpreted by many small spray-painting guns on the larger drum, and as they move slowly along the length of the drum, they spray the four process-color paints onto the paper. Paintings rendered with pigments similar to outdoor house paints provide years of fade-resistant beauty for these computer painted billboards.

In recent years there has been renewed

outlet, regulated by a small computer. Each fan keeps a different segment inflated; the computer is programmed to activate each fan at different intervals, if some type of movement is desired. The nylon is bolted to the billboard with three-inch bolts, so even intense wind will not tear it off the board, and the small fans can keep the objects inflated with up to a one-foot tear in them.

Messages literally leap out of the billboard in this new and sculptural third dimension, commanding the viewer's attention much more than a two-dimensional printed or painted billboard could. One liquor store in California enjoyed a 150 percent sales increase after displaying an inflatable of a Jose Cuervo tequila bottle for just one day.

Another trend in the production of billboard art has been developed by both the Japanese and

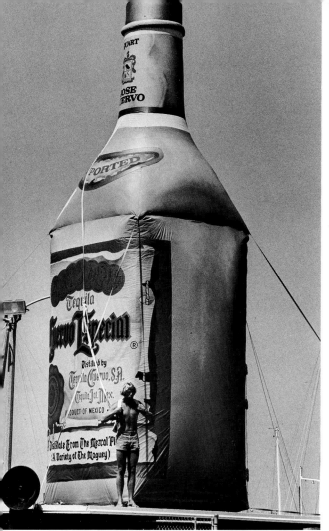

An inflatable tequila bottle, reminiscent of Pop artist Claes Oldenburg's soft sculpture, is the ultimate in three-dimensional outdoor advertising.

Solar-powered billboards will help to meet the energy needs of the 1980s. The back of a billboard model displays solar energy panels.

interest in the development of a solar powered billboard to meet the ongoing energy crunch. Although the 1980s will see more and more people traveling, working and shopping at night, illumination costs for billboard lighting could become prohibitive if alternatives are not developed.

But the real difficulty currently lies in the question of an inexpensive solar battery to store the energy created by the sun. Present billboards would have to be modified to hold not only the

solar panels, but also a bank of solar batteries stored and housed on the board. The cost of illuminating a fourteen by forty-eight foot billboard through solar power is estimated by experts at approximately $50,000 per year. The billboard must also be in certain locations where they can catch easterly light, and are not shadowed by buildings or trees.

Holography is a more difficult medium to adapt for billboard usage. Although holography does have the ability to project an object with the appearance of three dimensions, bright sunlight washes out the image. Therefore, a shadow box is required for greater visibility. However, since holography itself is still in its infancy, a practical use for it in outdoor advertising will very possibly develop, along with the medium itself.

Using a laser beam to write out a billboard message is now technically feasible. A computerized mechanism is still needed to move the laser beam through a pattern similar to handwriting. This would bounce the written laser message off the board, creating a spontaneous and glowing message. At the moment, the laser, like the hologram, would be suited to a nighttime effect.

Laser writing does still have a potential hazard, however, one that must be worked out. Aside from the possibility of pigeons flying into the laser beam and being blinded, the beam might also bounce and reflect into the eyes of an un-

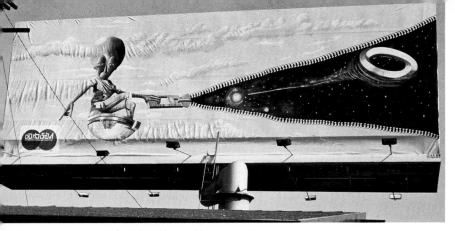

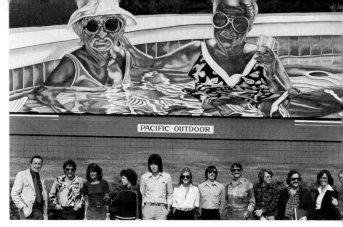

Groups of artists displaying original paintings on billboard formats will continue to take their art to the streets in similar programs around the world.

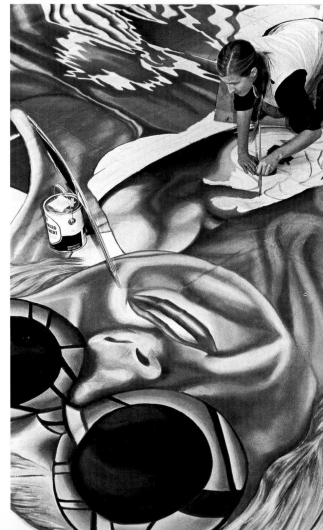

wary pedestrian if used improperly.

Panographics, a 3M product, utilizes airbrushed polyvinylchloride sheets, illuminated from behind to produce brilliantly visible nighttime effects. The panographic concept uses the PVC sheets stretched over the billboard frame. Instead of light bouncing off the face of the billboard, the board seems to glow internally. Since the panographic board is built much like a large-scale light box, the effect is more impressive than that of a billboard. But during the day, it looks much like a traditional billboard, which inhibits its production somewhat since it is more costly to produce than painted or printed billboards.

The notion that fine art should exist within the outdoor urban environment is not a new one. Sculpture and mural art have been a part of cityscapes for centuries. More often, however, these were made possible by private or corporate funding, and placed either at building sites or, as in the case of commissioned murals, at locations that were not readily accessible. A business might, for example, commission an artist to paint one of its walls facing the alleyway to brighten its side entrance. There are and have been various government-sponsored projects, but in times of fiscal cutbacks, these are often the first sacrificed, since many consider them unnecessary.

Billboard companies who already have all the means for showing contemporary art seem

the perfect patrons. They can loan their billboard spaces for periods of time to allow artists' work to be seen by an audience which even a museum could not reach. In return, the billboard company generates community goodwill as a response for enriching the places where people live and work.

A variety of artistic endeavors have been undertaken in cooperation with billboard companies. Artists have had their work reproduced on printed posters, and in several cases, the artist himself has painted his image on plywood panels or theatrical canvases, which were draped over the billboard frame and later preserved.

These sorts of associations between fine art and billboard advertisers will continue. Some companies have been considering large reproductions of work by masters on their billboards, or of museum pieces. In addition, there may be billboard showings of individual, contemporary artists in the future.

The days of the wealthy Renaissance art patrons are long past, but wealthier corporations have taken their place, buying billboard advertising art for the masses. A trend that may become more visible in the 1980s is the corporate-sponsored board, as more people battle inflation and multinational corporations work to improve and maintain their community image in the face of consumer dissatisfaction. These outdoor advertisements often feature announcements of

A museum exhibition of billboard art allows the public to view the special talents involved in re-creating King Tut's golden visage (below). Public service boards are gaining the public's attention and support with hard-hitting facts that previously were left unspoken (right).

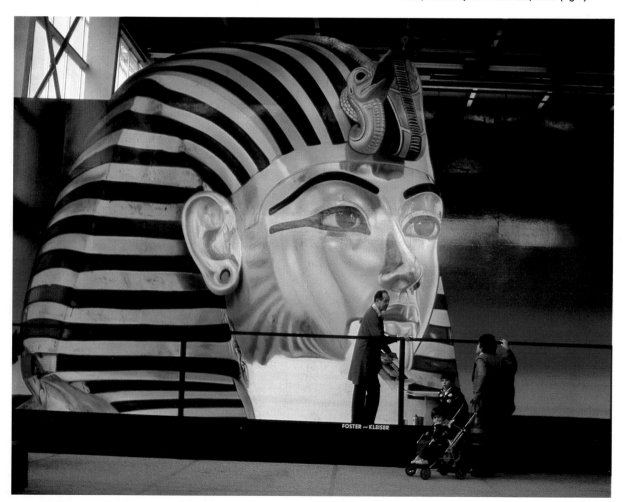

cultural events, or carry messages on behalf of community organizations—with the company adding its name, discreetly but visibly, to the board.

Outdoor advertising companies voluntarily give a certain amount of space to public service messages, unlike radio and television stations, which must do so to meet industry regulations. These boards feature only advertisements for non-profit, community service groups. A billboard

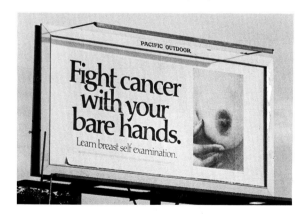

for the American Cancer Society drew fire several years ago when it pictured a woman's uncovered breast, along with a caption urging women to undertake regular self-examination. We might expect to see more public service boards in the future, with continued emphasis on issues formerly undisplayed.

*A billboard for the movie "Tommy" bridges
the gap between advertising and fine art.*

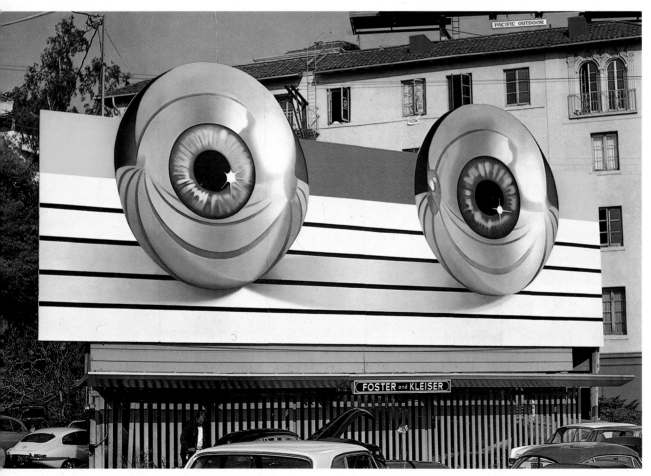

Billboards are an integral part of the twentieth century cityscape, disseminating information to the populace circulating around them. They can hide natural beauty, as well as urban blight, with their massive pictographic portrayals of society's current trends and desires.

To millions of travelers all over the world who pass before them, billboards are an extended lesson in art and sociology. Their printed and hand-painted images reflect thousands of years of traditional, realistic painting, as well as avant-garde movements that have slipped into the mainstream of the fine arts. They interpret and affect such current media as magazines, television, and film, as well as our living patterns—fashion, interiors, and product design.

Billboards can be many things: humorous, informative, political, artistic, and socially influential. Although advertisers in various countries use different approaches to reach their particular audience, certain fundamental rules are inherent in all good billboard advertising: be brief, be clear, be seen. But because of their high visibility, city planners, advertisers and companies must exercise responsibility in the face of environmental and aesthetic concerns. If properly placed and maintained, the billboard will remain an important part of visual communication in our society, and most certainly a mirror of man's endeavors.